CHESAPEAKE BAY RETRIEVERS, DECOYS & LONG GUNS

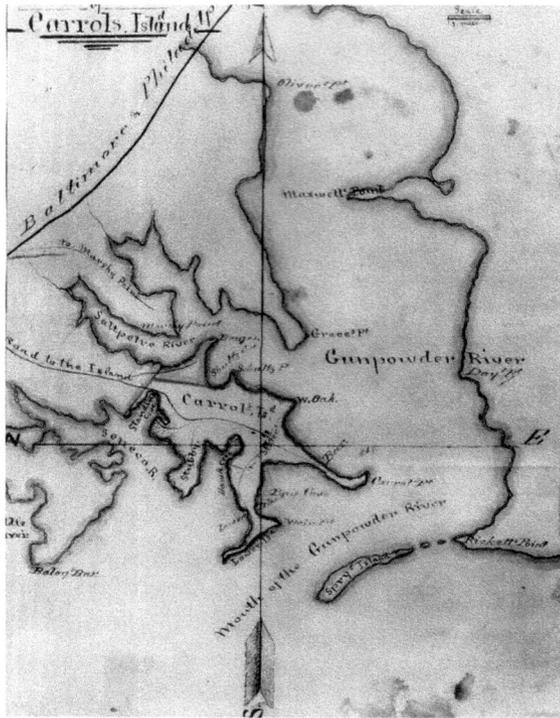

HAVRE DE GRACE DECOY MUSEUM

The Havre de Grace Decoy Museum is a privately funded, nonprofit educational institution that exists to document, preserve and interpret waterfowl decoys as this art form applies to the heritage of the Chesapeake Bay. The museum, situated on Concord Point overlooking the bay's Susquehanna Flats in Havre de Grace, Maryland, features a fabulous collection of decoy making tools and waterfowl hunting memorabilia, as well as working and decorative decoys from throughout the United States. Through its exhibits, special events and educational activities, the Decoy Museum celebrates this genuine American folk art.

C. JOHN SULLIVAN JR. ENDOWMENT

The C. John Sullivan Jr. Endowment Fund was established by the author to further the Havre de Grace Decoy Museum's interpretation, documentation, presentation and preservation of the history of Chesapeake Bay decoys and waterfowling. The fund's interest proceeds benefit the museum's publication program.

CHESAPEAKE BAY RETRIEVERS, DECOYS & LONG GUNS

TALES OF CARROLL'S ISLAND DUCKING CLUB

C. JOHN SULLIVAN

THE
History
PRESS

Published by The History Press
Charleston, SC 29403
www.historypress.net

All images from the collection of C. John Sullivan unless otherwise noted.

Cover design by Natasha Momberger.

First published 2008, Second printing 2008, Third printing 2014

ISBN 978.1.5402.1869.8

Library of Congress Cataloging-in-Publication Data
Sullivan, C. John.
Chesapeake Bay retrievers, decoys, and long guns : tales of Carroll's Island Ducking
Club / C. John Sullivan.
p. cm.
ISBN 978-1-5402-1869-8
1. Carroll's Island Ducking Club--Anecdotes--History. I. Title.
SK3.S85 2008
799.2'440975271--dc22
2007051859

Notice: The information in this book is true and complete to the best of our knowledge. It is offered without guarantee on the part of the author or The History Press. The author and The History Press disclaim all liability in connection with the use of this book.

I affectionately dedicate this book to my grandson,
HAMILTON BRADLEY SULLIVAN,
in hopes that he will learn to love, cherish
and preserve history in the tradition of both
his grandfather and Ferdinand Claiborne Latrobe II.

CONTENTS

FOREWORD

I spent many wonderful days ducking at Grace's Quarter Gunning Club. I can well remember hearing the guns at Carroll's Island when the ducks weren't flying at Grace's. The Carroll's Island Ducking Club, along with Grace's Quarter, Marshy Point, Seneca, Bengies and Maxwell's Point, provided waterfowlers from various regions and diverse backgrounds with great sport. C. John Sullivan's newest book not only provides the reader with insight into the sport, but also describes the competition for wildfowl and the resulting conservation efforts and brings the sportsmen who gunned there, and the noble animals who hunted with them, to life once again. The book provides the reader with an in-depth look at Maryland's state dog, the great Chesapeake Bay retriever, and the reverence that early sportsmen held for these dogs. John Sullivan has once again produced an up close and personal look at a time long gone and a history that would be lost to all if not for his efforts.

J. Fife Symington Jr.

PREFACE

I have been extremely fortunate in my lifetime to have met a few gentlefolk whose impact on me will remain. Some were old-time decoy makers. One was the son of a freed slave who made axe and shovel handles using the same centuries-old tools of his ancestors and lived on and farmed the land his father had purchased as a freeman. Others were old-time trappers, watermen and waterfowlers or their children. But outstanding in those memories are a few who belonged to or had family ties to some of Maryland's most select clubs, the ducking clubs of old Maryland. Two of these men, the late T. Edward Hambleton and the late J. Fife Symington Jr., became good friends and shared with me great tales of gunning at the Grace's Quarter Gunning Club. I met these gentlemen in 1991 while serving on the Sporting Art Committee at the Maryland Historical Society. Little did I realize at the time what a rare breed of gentlemen I had met. Both of them had gunned at Grace's as young men—their fathers had been members there. The two told great stories of those days and related to me that, when the ducks were not flying at Grace's, they could often hear the gunners at Carroll's Island, Bengies, Miller's Island or Maxwell's Point firing away at the migratory flocks. Through the years I also became acquainted with Mary Helen Cadwalader and her brother, Benjamin Cadwalader. Their family owned the famous shore estate known as Maxwell's Point. They both remembered being there as children and shared family memories and photographs of that wonderful property. Another was Harry Weiskittel,

whose father had purchased the Marshy Point Gunning Club property from the Alexander Brown family. The Weiskittels are extremely blessed to still live on the Marshy Point estate. All of these gentlefolk shared their knowledge and memories of a time long gone. Each was a humble sharing person, as fascinated with their family history as I was. I gained personal insight into these early clubs through each of them and have shared this knowledge with others in my writings.

And now I have been honored to have been brought into the world of the Carroll's Island Ducking Club by the generosity of the heirs of Ferdinand Claiborne Latrobe (1833–1911), a mayor of Baltimore, and his son, Ferdinand Claiborne Latrobe II (1889–1944). It was in the early fall of 2005 that I was left a telephone message by a gentleman by the name of Ferdinand Latrobe. I listened to the message several times to convince myself it wasn't a hoax. The name was familiar to me. I knew it to be the name of the mayor of Baltimore for multiple terms, a name that is deeply embedded in the history of not just the city but the state as well. The first Latrobe in America whose history I was familiar with was Benjamin Latrobe (1764–1820). He had been a friend of Thomas Jefferson; he was the architect of the United States Capitol and the oldest Catholic cathedral in the United States, the newly restored Basilica of the Assumption in Baltimore. I also knew that Mayor Latrobe, who was also known as General Latrobe—he served as judge advocate general under Governor Hicks—had been a member of the most famous of Maryland gunning clubs, the Carroll's Island Ducking Club.

The Ferdinand Latrobe who left me the telephone message was the great-grandson of the mayor and the grandson of Ferdinand C. Latrobe II. He said in his message that he had just finished reading my book, *Waterfowling on the Chesapeake, 1819–1936*, and that he had some material that might be of interest to me. We agreed to meet on October 5, 2005, for lunch at the historic Maryland Club in Baltimore City, the oldest private men's club in the city, a club where his great-grandfather had been a regular. Ferdinand Latrobe brought along some gifts and materials for my perusal, including a cookbook authored by his grandfather and illustrated by Yardley, the famous local illustrator. His second gift was a complete shock to my history-loving sensibilities. It was a thick, multiple-chapter, loose-leaf volume containing the carefully assembled and typed notes of Ferdinand C. Latrobe II, relating the history of the Chesapeake Bay and some of its famous gunning clubs, including the Carroll's Island Club. My guest's brother, John H.B.

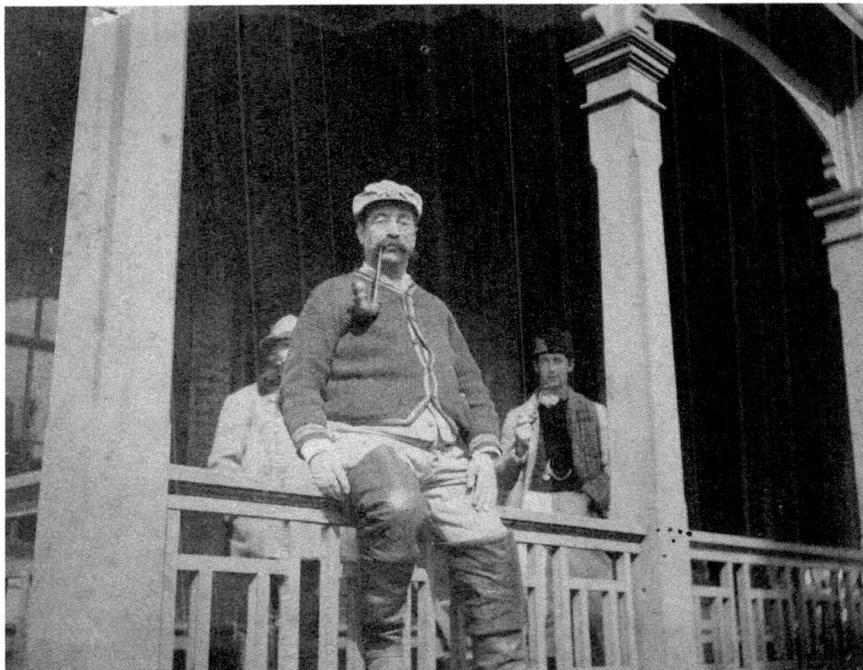

General Ferdinand Claiborne Latrobe, mayor of Baltimore and sportsman, relaxes with his pipe on the porch of the Carroll's Island Ducking Club in 1886. His remembrances of those days were preserved for posterity by his son, Ferdinand Claiborne Latrobe II. *Collection of the Latrobe family.*

Latrobe, had carefully transcribed this volume from his grandfather's typed drafts and handwritten notes.

This material, so meticulously researched, so lovingly preserved for future generations and so generously shared, has been of immeasurable assistance to me in my endeavor to preserve the history of the Carroll's Island Ducking Club. The extent of my gratitude to these gentlefolk cannot be expressed.

ACKNOWLEDGEMENTS

Throughout the writing of this history and dreaming of what life was once like at that place and at that time, my mind stayed focused on the past and now looks to the future as I write these final words. A few things that come to my mind—usually in the middle of the night—are how did I balance all of the things in my life, how did I find the time to write these words, how many people helped me with this project and then the fear that it is almost done and oh my what will I do next. On many mornings in my life someone will ask if I saw this show or that show on television or did I read this article in the newspaper and I am forced to muddle through the answers, as I have a TV that gives me fuzzy reception on one or two channels at best and I have little or no time to read a newspaper. But now who do I thank, how did I get this done and where do the inspiration and drive come from? I think back to my family history, my genealogy charts, the questions of where did I come from and what I am made of that I have considered. I reflect on so many segments of my own past. I recall a day in my seventeenth summer when I discovered a neat little blue box hiding in the upstairs of my family's springhouse in Fallston. It was a hot summer day, and I was keeping a watchful eye out for a nasty wasp or a big black snake to come out of a dust-filled corner of that old building. This is the building where my father and grandfather churned butter from the milk our family's cow gave. This is the same building where we floated watermelons in the cold spring water for our Fourth of July picnic. Tucked away behind an old

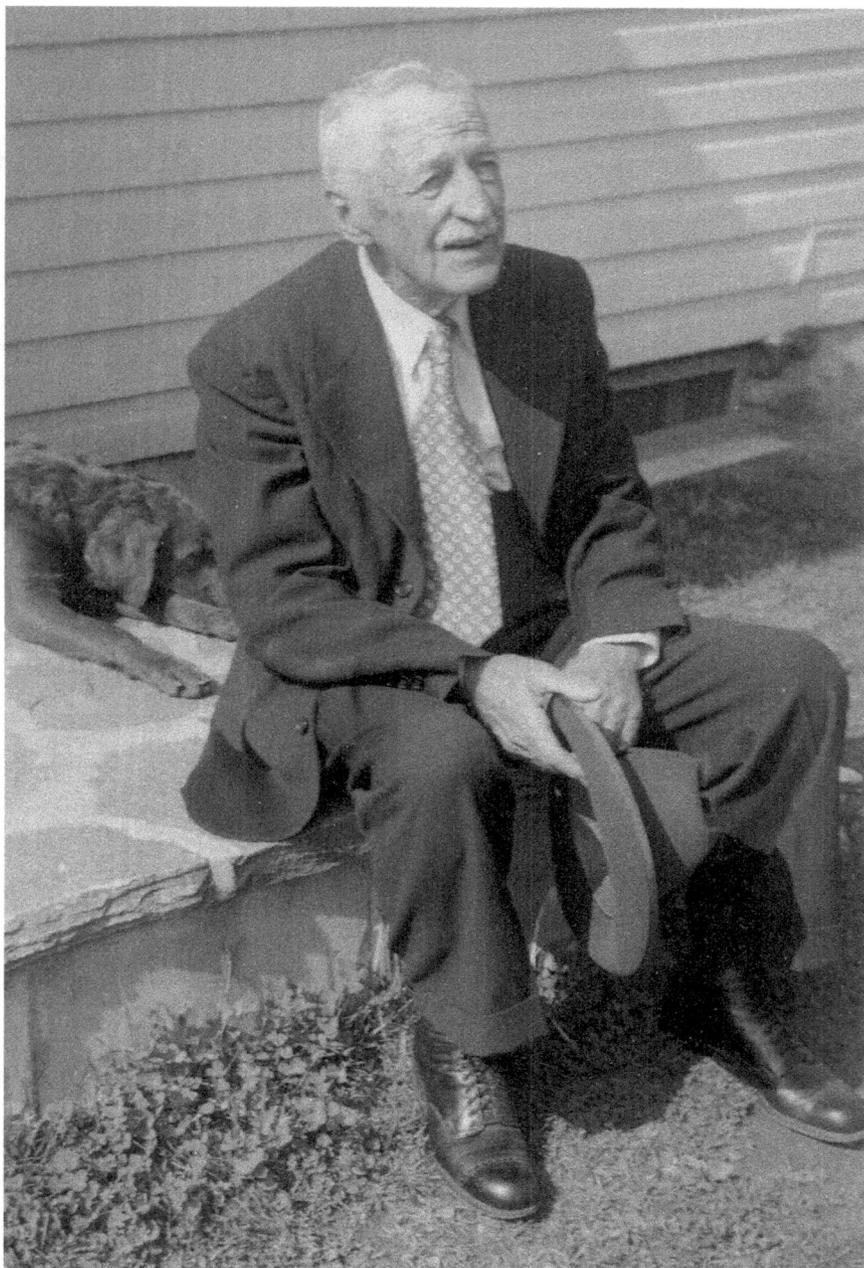

Robert Henry Sullivan, "the boy of the cook," on the porch at Stoney Batter with his Chesapeake Bay retriever, Monty.

table where tomes from my family's school days rested I spotted this box; I slid it across the wide pine floorboards and brushed off the top—inside were a bunch of little blue cloth-covered journals. I opened one up and it was the time book from Pop Sullivan's days as bridge and building foreman for the Maryland and Pennsylvania Railroad. I picked up one and put down another; there were notes in some of them and personal notations about the weather. Here they were, all of Pop's time books from the Ma and Pa. Detailed descriptions of where the "gang" was working and who was doing what were documented. Each little journal included a descriptive listing of work on this historic rail line. An accident report was stuck inside one of the books, describing my grandfather's handcar being struck by a Model T Ford at a crossing near Deer Creek in what is now the Rocks State Park. I brushed off the little box and carried it down with the time books inside. The box was lined with old wallpaper, had wonderful, diminutive rat tail hinges and there was something painted on the top of it. Painted over the blue milk paint was an address: Care of W. Scarff Stage Driver Fallston Station. I stop and think about this box; it traveled in a stagecoach through Harford County before there were cars or trucks. Why did my grandfather save these time books dating from 1918 forward and why did he decide to preserve them for his grandson to discover in a box that would become a cherished artifact? If I could select a single incident, a single item and one person in my life that led me to these pages it is this. For all whom I will thank and for all those who support me in these writing journeys, it was the "boy of the cook" that coaxed these words and pages from me.

Those who assisted me in this endeavor include former State Senator C.A. Porter Hopkins, whose personal archives and narratives of the early Maryland gunning clubs were invaluable; former United States Ambassador J. Fife Symington Jr., who provided constant support and firsthand accounts of his days at Grace's Quarter Gunning Club; decoy carver and collector Patrick Vincenti, who promised me a Carroll's Island decoy over thirty years ago and finally delivered on that promise; John Cadwalader Jr., who provided me with new information about Maxwell's Point and the wonderful Cadwalader years there; Frederick Mitchell, whose knowledge of the army and the taking of Harford County lands was a great asset to this story; collector and friend Ronnie Newcomb, who provided me with a wonderful Hardcastle decoy; Harry G. Hopkins, whose family lived at Cranberry Farm, added personal knowledge of days in the fields after the army's takeover; former Harford County assessor

Acknowledgements

John G. Arthur, who insisted for many years that out there somewhere were the breeding records of the Chesapeake Bay dogs; Sam Dyke of the Ward Museum for making the by-laws of the Carroll's Island Ducking Club available to me; Roger J. Colburn for his wonderful map work; Tom Nicholson for his photography; Dr. Edward C. Papenfuse and the staff of the Maryland State Archives for their assistance in researching early land records; the United States Army for preparing and releasing their files on Carroll's Island and the gunning clubs that operated on the army's land; and fellow author John V. Quarstein, director of the Virginia War Museum, whose editorial recommendations certainly improved this book. The Maryland Historical Society is a treasure-trove of invaluable information, and the staff there was always accommodating. My "research assistant" who shares my love of history made this task happen. Kaye B. Bushel was always available and kept me on target to see this book to its end. Her drive and dedication to the project was untiring.

I cannot thank my dearest ones enough but I try, so I thank my son John, his dear wife Mary and my two delightful grandsons, Benjamin and Hamilton. They encourage me, they energize me, they make me write about our past but look forward to what the future may hold. Finally, I must thank my past, my present and my future inspiration, my dear mother Sara, who as I leave her house most every evening never fails to ask, "Now Johnny, are you going to write tonight?"

INTRODUCTION

Growing up in the Fallston area of Harford County afforded me many opportunities to experience life in a delightful, rural, agriculturally based community. The picturesque Maryland and Pennsylvania Railroad ran through the rear portion of our property, and my paternal grandfather's employment with the Ma and Pa as a bridge and ballast boss entitled me to a bit more access to the railroad than that of some of my childhood friends (at least I thought that it did). It was a small world. Mr. Henry Wilson still farmed with his team of horses. As I would walk each morning to the school bus stop, Mr. Henry would be delivering milk cans to the railroad platform to be shipped to the dairies in Baltimore. The school bus was a Chevrolet Suburban with a little letter "b" painted on the side of it. Mrs. Chenoweth drove "little b" and her husband drove "big B." I wonder now why, with only four buses delivering children to the two-room schoolhouse in Fallston, it was necessary to give the buses letter identification. But such was life in this part of the world in the early 1950s.

My father had gone to work as an assessor for the county in 1948, and I would get to go "in the field" with him a few times each summer vacation. These trips broadened my perspective of the region. I would visit farmers throughout the county with him, have a Popsicle for dessert after my peanut butter and jelly sandwich in the "upper end" near the Pennsylvania line and, if I was real lucky, I would get to hold the end of the tape measure to help measure the rare new house that was being built

on a lot sold off by one of the farmers. There were no developments, no subdivisions, no McMansions. The year before his death, my father drove me to an area he wanted me to see; it was called Joppatowne, and it was being built adjacent to the Little Gunpowder River on the Baltimore County line. "This is going to change things, Johnny, our County will be different now," he said. I had no idea what he meant by that but I would find out in time. It did change things forever; it opened up the county to those who were looking for a more rural environment in which to raise their families. Those one thousand new homes became many more thousands and changed a way of life forever.

In 1966, my father was gone and now I was an assessor working for the county. Grayson Hopkins, the very same man who had trained my father in the late 1940s, was training me. Grayson's perspective of the county was much different than that of my father. He had grown up on a farm, Cranberry, that was not developed with houses, but instead had been taken over by the United States Army for the United States military reservation known as the Aberdeen Proving Ground. Grayson introduced me to that area of the Upper Chesapeake region and would often say "the best part of the county is gone to the army forever."

It was about that time that I became interested in this part of the Chesapeake and the fascinating waterfowling history associated with it. In addition to my interest in the history of the area, I developed a passion for the antique wooden duck decoys once used there. When word got out that I liked these historic pieces of wood, my acquaintances put themselves on the lookout for them. Old friends would bring me decoys and offer them to me for sale, or occasionally give me one in which they had no interest. Over thirty years ago, an old friend, the late Leonard McGrady, a builder from Aberdeen, came to my office in Bel Air and handed me a grocery bag. I said, "What's this?" He replied, "I think you like these things, and they mean nothing to me." I opened the bag and discovered two old decoys, one a diminutive bluebill and the other a redhead hen wearing its original dull flat brown paint and a brand on the underside. The brand read "Carrolls Island." It was to become the very first decoy in my collection with the brand of a gunning club. That historic decoy acted as a focal point for my decoy shelves and, at the same time, kept my attention focused on the history of that early gunning club. In every early book or magazine article I read about gunning on the Chesapeake Bay, I would check for the words "gunning club," "Carroll's Island" and

"Gunpowder River," seeking anything that would aid in my search for more details of that historic time and place.

In the early 1980s, I toured the vast areas of the Gunpowder Neck. Standing on that portion of the Edgewood Arsenal known as Maxwell's Point, I asked my friend, the chief scientist of Edgewood, Dr. Prescott Ward, what land mass I was viewing across the Gunpowder River. It was Carroll's Island. He took me there that day to walk the shoreline and inspect the remnants of the foundation of the clubhouse. The only structures on the island were an observation tower and a small block building that housed toxic chemicals. I distinctly remember one remark that Dr. Ward made to me that day. When I asked what use the island had been to the army, he advised me that every toxic chemical known to man had been tested there.

As today's county residents travel up and down U.S. Route 40 and the I-95 corridor, I wonder how many know what lies between their route and the Chesapeake Bay, those 79,000 acres of waterfront and marshes that the average person never sees. My guess is that many have no idea of what that vast area once was, what it was used for and why and how the United States came to own it.

Aberdeen Proving Ground occupies those 79,000 acres of land and water in southern Harford County and southeastern Baltimore County, near the head of the Chesapeake Bay. Included in that acreage is the former Edgewood Arsenal, now known as the Edgewood Area of the Proving Ground, that occupies 17,000 acres separated from the Aberdeen Area by the Bush River. It is composed of the Gunpowder Neck, Pooles Island, Carroll's Island and Grace's Quarter. From 1917 to the mid-1970s, as Dr. Ward said, the Edgewood Area was used to conduct chemical research, to manufacture chemical agents and to test, store and dispose of toxic materials. It was an open-air test site for blistering, nerve and other chemical agents.

This book tells the story of Carroll's Island, the men who gathered there for sport from the 1820s up to the beginning of World War I, its more limited use by a few sportsmen until the late 1940s and the ultimate fate of this sportsmen's paradise.

THE EARLY YEARS

The earliest records of Carroll's Island are found in Maryland's land patents. A portion of the island was patented to John Lee of Virginia in 1665 and became known as Lee's Island. Other island tracts were patented by 1674 to James Phillips and John Chadwell and bore such names as Phillip's Addition and Chadwell Range. During that period, the island was known as Phillip's Island. It became known by its present name by 1745, when Charles Carroll surveyed a 334-acre island tract that was then patented to him in 1746. His son, Charles Carroll the Barrister, continued to acquire island property after his father's death in 1755. The typical method of acquisition at the time was to continually resurvey, each time extending the boundaries of the property. An 898-acre tract that comprised the entire island was patented to him in 1770 and named Clonish Carroll's Island after the family's lands in Ireland. The island was surveyed many times over the ensuing years with varying results. The Baltimore County Assessor's Field Book for 1841 fixes the acreage at 1,000 acres. When the island was resurveyed for the U.S. government's taking in 1917, the acreage was determined to be 1,212 acres. The Carroll family had vast landholdings in Maryland, and there is no record as to what if any use the family put to the island in the latter part of the eighteenth century. The Latrobe history indicates that Charles the Barrister acquired and named one tract the "Shooting Ground" prior to his death in 1783, which suggests that at least one of the attractions of this island was the plenitude of wildfowl.

When Charles the Barrister died, the ownership of the island went to his nephew, Nicholas Maccubin, who took on the surname Carroll as

a condition of his inheritance. Upon his death in 1812, the ownership passed to his niece, Mary Clare Spence. A worn, leather-bound volume that currently resides in the library of the Maryland Historical Society contains the handwritten record of the personal property owned by Nicholas Carroll upon his death. One entry is entitled "Inventory and appraisement of the goods & chattels of Nicholas Carroll Esq. late

Inventory and appraisement of goods and chattels of Nicholas Carroll, Esquire, late of the city of Annapolis, deceased, remaining on his farm called "the Island" lying in Baltimore County. *Maryland Historical Society.*

of the City of Annapolis deceased remaining on his Farm called 'the Island' lying in Baltimore County." The only property listed is the names, ages and value of twelve Negro slaves ranging from twelve to sixty years of age. Included on the list was "Tuck an Idiot," age sixteen, who was valued for less than a dollar. The presence of these slaves, who included in their number three men between the ages of twenty-one and thirty, suggests that some regular activity, most likely farming, was conducted on the island.

In 1833, Mary Spence joined in a petition to the Maryland legislature with neighboring property owners and sportsmen protesting against the firing of "swivels or guns so large that they cannot be fired from the hand but must be fired from a rest" from any skiff, boat or float, and any night shooting from land or water in the waters of the Chesapeake Bay in Baltimore County, including the Patapsco and Gunpowder Rivers. The petition described the consequences of this protested activity:

> The consequence is that the wild fowl, and particularly that species almost peculiar to the waters of the Chesapeake and for which they are deservedly so celebrated (The Canvass Back-ducks), by being so frequently disturbed and killed in such masses, have of late years greatly diminished in number, and if some remedy be not supplied by your honorable body, will shortly entirely disappear from our waters. The value of our lands in a great degree depends upon the facility which they afford us of furnishing wild fowl both for our own use and for that of the public.

This petition suggests the importance of the abundance of wildfowl to the owners of the large tracts of land bordering the Chesapeake and its tributaries and the competition for the best shooting. It was signed by thirty-seven individuals, including Robert Oliver, the owner of Harewood on the Gunpowder; Tobias C. Stansbury, the owner of another Baltimore County shore; and Frank Sullivan. There was apparently ample reason for concern for the preservation of the wildfowl, as the fame of Carroll's Island was well established by 1829 when the writer of a "Sporting Olio" published in the *American Farmer* queried, "How would the best day's English sport compare, *for the table*, with one day's *canvass back* shooting on the wing, at Carroll's island?" Another article, entitled "Duck Shooting on the Chesapeake Bay" published in the August 1833 issue of the *American Turf Register*

and *Sporting Magazine*, reported, "Carroll's island, at the mouth of the Gunpowder river, opposite Rickett's Point, is the best place to kill ducks in the state of Maryland, not excepting Miller's island...The Havre de Grace sharpshooters have it in contemplation, next fall, to rent some convenient place near this island, and range their floating battery every morning in a line with the bar that connects the island with the main land."

The legislature had enacted an act for the preservation of wildfowl in the waters of Harford County during the 1832 legislative session; this petition resulted in the extension of these provisions, as amended, to Baltimore County in the 1833 session.

Further proof of the popularity of wildfowl shooting is found in newspapers of the time. It was not uncommon to advertise the sale of "plantations" with an abundance of wildfowl in season, as well as the availability of English "fowling pieces" for sale. In January of 1805, the *American and Commercial Daily Advertiser* contained an advertisement for the sale of "Ketland's Fowling Pieces" by the merchants Muir & Slurey at 79 Smith's Wharf, as well as an offer for lease of Enloe's Point plantation on the lower end of Middle River Neck, which advised that "no place as near the city possesses greater advantages from the water, in fish and fowl, in the proper seasons."

It is the documented existence of "clubs" that confirms that the pursuit of wildfowl even in these early years was for sport—albeit in competition with the market gunners who even then slaughtered masses of wildfowl. One early reference to the existence of a "club" for sportsmen at Carroll's Island is found in the October 1829 issues of both the *American Turf Register and Sporting Magazine* and the *American Farmer.* Alfred Jones of Queen Anne's County directed his advertisement for a "FLYING KITE" "*To the Members of Carroll's Island Wild Fowl Shooting Club.*" The function of the flying kite was to divert wild fowl on the wing toward the sportsman, particularly "when the sportsman is on a long duck bar, or narrow strip of land, such as Carroll's island." The lengthy article on duck shooting on the Chesapeake Bay in the August 1833 issue of the *American Turf Register and Sporting Magazine* noted that the island was "rented by a club by the rules of which no member is permitted to invite his best friend. Such a rule does not exist any where else in the state."

We have the benefit of two eyewitness accounts to the early "club" years at the island. On October 27, 1834, John Stuart Skinner introduced Tyrone Power, an Irish comedic who was playing an engagement at the

Holliday Street Theater in Baltimore, to the island. They each wrote of the visit—Skinner in an article first published in *Turf, Field and Farm* and Power in his two-volume journal, *Impressions of America*, published in 1836.

Power's journal reads:

> *27th.—Accompanied Mr.__r to Carol's Island, having arranged to visit this celebrated ducking-ground on our way to Mr. Oliver's seat.*
>
> *We reached the house about eleven o'clock, the distance being sixteen miles: the cottage which forms the head-quarters of the club of gentlemen who farm this sporting stand, was plain enough for the most republican spirit. One sitting-room, and a couple of dormitories containing a camp-bed for each member, with pegs and racks for arms and implements, formed the whole of the appointments and furniture; but the sport is first-rate; and the plain simplicity of the ménage gives increased zest to the meeting, and promotes the hardihood essential both to the successful pursuit of game and to the healthful enjoyment of the sport.*
>
> *Before the hour of dinner, we walked down on the long neck of land where the shooters patiently abide the flight of the ducks: on one side is the Seneca, and on the other the Gunpowder river; both favorite feeding-grounds of all the water-fowl frequenting this region of creeks, rivers and bays. About the central line of the neck of land, a dozen or so of stands are ranged at equal distances, built about four feet high, each large enough for two gunners; with shelves within for the various traps needful, a plank floor, and a couple of stools.*
>
> *Here the men on duty take post; and, chewing the quid of "sweet and bitter fancies" patiently abide the moment when it may please the canvass-back to give his bosom to the breeze, and quit one river for the other.*
>
> *At two o'clock we sat down to a most capital dinner,—a joint of roast beef, fine fish, and Canvass-backs, that had been on the wing within a couple of hours, together with the Redhead, Teal, and two or three other specimens; all excellent in their way, but not comparable for delicacy, fat or flavour with that inimitable work of nature the right Canvass-back duck of these waters, where the wild celery on which they love to feed abounds, and to which they owe the delicate aromatic flavour so prized by the gourmand.*

Skinner identifies two other participants that day, General Cadwalader (who later owned Maxwell's Point) and a gentleman identified only as "Chapin." He mentions that the Ridgelys, the Johnstons, the Sullivans

[Vol. 1. No. 2.] AND SPORTING MAGAZINE. 95

FLYING KITE.

To the Members of Carroll's Island Wild Fowl Shooting Club.

SPORTSMEN ATTENTION!!!

Probatum est.

Conticuere omnes, intentique ora tenebant.

Sir,—Presuming that you will cheerfully insert whatever contributes to the recreation of the land proprietors on our bay, river, and creek shores, I beg leave to make known the practical efficiency of the *Flying Kite* for making all kinds of aquatic wild fowl on the wing, approach near to the sportsman stationed with his gun on the point, or shore side.

The kite which I use for this purpose, as a *Ruse de Guerre*, has its frame constructed of cane, and according to the English mode, is three feet by two feet and a half superficies, covered with scarlet coloured thin florentine silk, so as to be of the greatest attainable lightness for flying with as little wind as possible, that it may be put into operation so much oftener than could be done were it heavier; and consequently requiring more wind to fly it. The scarlet colour is adopted as being the most conspicuous of all others: and silk is used for the covering in preference to any thing else, that it may not be injured, or put *hors de combat*, by incidentally falling into the water. The tail consists of about twenty feet of twine, having at its lower extremity a piece of cane one-fifth of an inch diameter, and two feet in length, transversely placed; to each end of which a foot and a half of twine is attached, and the other ends tied together so as to form a triangle. Assuming the piece of cane for its base, the edge part of two feet square of thin florentine (scarlet colour) silk is sewed round the whole length of the cane, so as to subtend it, and constitutes a tassel, which keeps extended, and by its flaring exhibition, thus appended by the apex of the triangle to the end of the tail, has the greater effect of making the wild fowl in flight approximate the sportsman. Ninety feet of twine, with a tassel at the lower end of it, of similar materials and construction, is fixed by the upper end round the middle of the cane of the kite's tassel. This second tassel is for the purpose of producing the same effect on the wild fowl flying much lower. About ninety feet of twine is also fixed by the upper end, round the centre of this second tassel's piece of cane, having two inflated supernatant hogs' bladders painted of a scarlet colour, with vermillion and spirits of turpentine, for a tassel, suspended at the neck by three feet of twine each, and being tied together at the other ends, appended at the lower extremity of it, for the purpose of making the wild fowl on the wing, near the surface of the water, approximate the sportsman.

96 AMERICAN TURF REGISTER [Oct. 1829.

Inflated supernatant hogs' bladders, near the surface of the water, are preferable to any thing else, should the decrease of wind occasion their descent, as their weight becomes immediately removed by their floating. The greater or less force of the wind will indicate the capability of the kite's sustaining and flying with the three tails, two, or only one. When with only two, the painted hogs' bladders are to be substituted for the second scarlet coloured silk tassel. The complete apparatus is here figured.

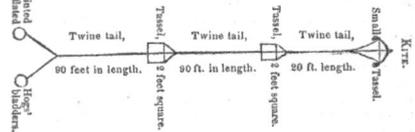

This *Ruse de Guerre* of the flying kite, is a *sine qua non* on our bay, river, and creek shores, not having any point; or duck-bar; as it, notwithstanding, brings the wild fowl on the wing within killing distance. It of course requires nothing more than adequate force of wind to effect the flying of the kite, either blowing on or off shore, or up or down the water. If on shore, when the river or creek is narrow, put a servant across to fly the kite from the opposite side; and let him know by the signal agreed upon to be made when the kite is in proper positional flight as to distance from you; when also to let her move out toward you, by giving more string; or to take her further from you by winding up some of it; according as one or the other is designated by the effect on the flight of the wild fowl, so as to be favorable or not, in throwing them near enough to you, or too much beyond your station.

When on the bay, or wide river shore, and the wind is blowing on shore, this same stratagem may be put into operation, by sending out a row-boat, the kite being carried in its full length of string flight from the shore, on first starting from it in the row-boat, and held aboard in flight all the way out. And as soon as the boat is far enough off shore for the kite being in suitable position for influencing the wild fowl, on the signal being given by the sportsman ashore to the persons on board the boat, the anchor is to be dropped, with the kite string tied to a piece of leading line rope attached to the cable of the anchor, of a length according to the depth of the anchorage, and the kite left flying; the boat being brought ashore and concealed from the wild fowl; as, if it remained out at the anchorage, it would cause them to fly

Vol. 1. No. 2.] AND SPORTING MAGAZINE. 99

the swans, geese and ducks, under the most adverse circumstances, *nolens volens,* not only within killing distance, but (nautically speaking) close aboard.

Your respectful and ob't serv't, ALFRED JONES.

Queen Ann's Co. Md. July 19th, 1829.

In July 1829, Alfred Jones of Queen Anne's County advertised the Flying Kite, a device designed to attract wildfowl to the point or shore, to the "Members of Carroll's Island Wild Fowl Shooting Club." American Turf Register and Sporting Magazine, *October 1829.*

and the Duvalls were frequent visitors to the island during those years. Skinner described Power's shooting that day, noting that while he was a fair shot at all other feathered game, he had no experience with wildfowl. Apparently his shooting improved as the morning progressed, though "the truth is he could not well help it, for at times the birds passed over in such solid squadrons that to make a blank shot was an exception. At one time the firing was so rapid as to make the gun-barrels unpleasantly hot."

Mary Clare Spence, who inherited the property from her uncle, Nicholas Maccubin Carroll, was most likely leasing gunning rights to these gentlemen by the 1820s and perhaps even earlier. By 1834, the island was leased to James Moir, Stephen Thompson and James Gibson, and within the next several years it was transferred to James Moir, with a reservation of a ground rent to the Spences. Both S.P. Thompson and James Moir signed the 1833 petition to the legislature. The Assessors Field Book for District 2 in 1841 contained the following entry: "Moore James on Carrols Island has Negros males 2 under 14 years females 2 between 14 & 26 has 3 horses $50 & 5 mules $50 & Cows 15 head $115 hogs 50 head $250 & sheep 40 head $150 & furniture $700 Land 1100 Acres Carrols Island boat and seine $125 imp 1000."

It is believed that between 1838 and 1840, Moir built the large brick house on the property that in later years became the clubhouse for what was to become the Carroll's Island Ducking Club. By 1840, the island was in the hands of Colonel William Slater, the former steward of Robert Oliver of Harewood, his estate on the Gunpowder. Slater was apparently associated with the island prior to that time, since Frederick Skinner in his description of his 1834 visit with Tyrone Power indicated that arrangements for the visit had been made with "Old Slatter the loquacious Boniface of the place."

The men who frequented the island in these early years were predominantly Baltimore businessmen and bankers. Skinner suggested that these men were secretive about their sport due to "the fact that to be known in those days as a sportsman might injure the credit of a business man." He imagined these early sportsmen's trips:

> *I fancy I can see the old fellows now, shutting up their offices at noon on Saturday then skipping into Dick Smith's cellar—Dick was a mulatto and the Delmonico of Baltimore—for their preordered lunch*

of terrapin and mill-pond oysters and while so engaged, a darky from Woodruff's livery stable would bring to the door a buggy and pair. In the bottom of the vehicle, discreetly concealed by a buffalo-robe, would be three or four ancient flint-lock fowling-pieces of inordinate length, and a runlet or demijohn of fine old Otard or honest London Dock from Norfolk. Then the old cocks would issue forth in that delightful state of beatitude always attendant upon the easy digestion of a luxurious meal, and mounting their wagon, leave town ostensibly on important business, but in fact, wholly intent on reaching the Island in time for the evening flight of the ducks. The next day, but always after dark, they would return to the city with the wagon-bed filled with a noble spoil of canvas-backs, redheads, blackheads, and bald-pates, with now and then the addition of a swan.

In addition to General George Cadwalader and members of the Ridgley family, one of the early sportsmen who frequented the island and who perhaps gunned there for a longer period than any other

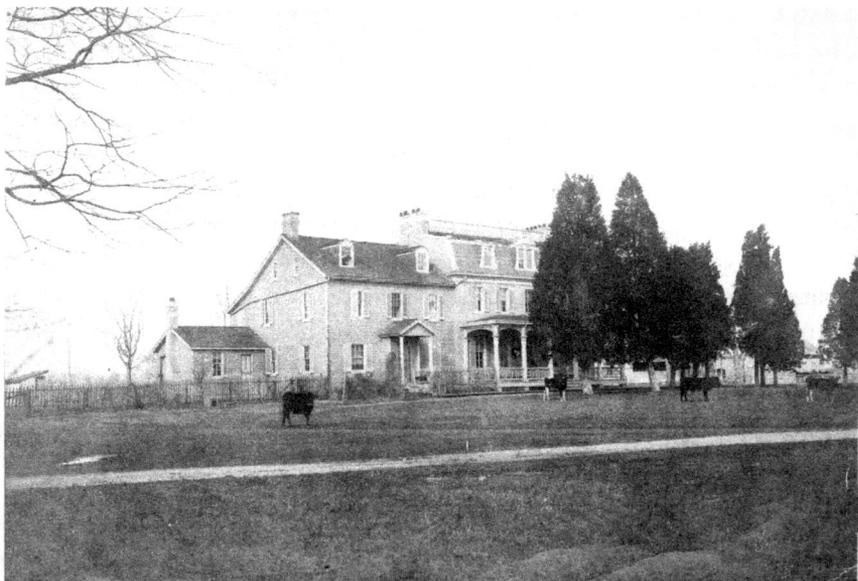

The famous Carroll's Island clubhouse. The large, brick house, believed to have been built by James Moir between 1838 and 1840, was expanded by the wooden addition in the 1880s. *Collection of the Latrobe family.*

was John H. Duvall. Born in 1809 and in the dry goods business in Baltimore, Duvall was described by Skinner as "Uncle John Duvall, the Nestor of Chesapeake duck-shooters, and the best shot at wildfowl in all Maryland." We know Duvall was gunning on the island at least by 1834 from Skinner's account, and his name still appears in club records at the conclusion of the Civil War. According to General Latrobe, Duvall shot at the island until 1884. Another early participant was Thomas Donaldson Johnston, a Baltimore banker associated with Josiah Lee. Lee and General George Cadwalader acquired together the first parcels in the assemblage of Cadwalader's vast estate on the Gunpowder Neck, Maxwell's Point. In later years, Johnston's son, Henry Elliot Johnston, also gunned at Carroll's Island.

As the *American Turf Register and Sporting Magazine* observed in April 1830:

> *Those who have never witnessed it, have little idea of the number, weight and quality of fine ducks that are sometimes brought down when on the wing at Carroll's Island, in a day's shooting.*
>
> *On one day, in November last [1829], a few gentlemen, of whom Capt. Robinson, of the Union Steamboat Line, and his brother, were two, killed, as they flew over the bar, 150 fine canvass backs and red heads; their dogs were exhausted or they would have got more; as it was, they had to send for the ox cart to take them home. Before long we shall be sending them by a comet or a meteor to London; with a good canvass back, seven pounds to the pair, what dish can compare that ever smoked on an Alderman's table.*

The Captain Robinson referenced was Daniel Robinson, a resident of Baltimore and the captain of the newly built steamboat *Independence*.

Colonel William Slater continued the practice of leasing portions of the island to sportsmen. The Baltimore newspaper, the *American and Commercial Advertiser* of September 19, 1846, reported the following incident:

> *Fire at Carroll's Island.—This delightful island suffered by fire yesterday, when one of the farm houses of Mr. Slatter, the gentlemanly and popular proprietor of the island, was burnt to the ground. The building was situated about one mile from the principal house and the fire broke out in it at three o'clock in the afternoon, and although*

about a dozen Baltimoreans (some of them most excellent firemen) were rusticating there at the time, and who promptly repaired to the scene of destruction, they were unable to stop its progress until it destroyed the building. Most of the contents were removed in safety. The fire was purely accidental. The loss was about $800, and there was no insurance on the building. It had just been rented to a club of gentlemen of Baltimore for the purpose of gunning and fishing.

THE CLUB YEARS

Rules, regulations, memberships, dues, minutes and a clubhouse—all of these things are part of being a member of "The Club." As many of my generation did, I grew up watching *Our Gang* and *The Little Rascals* on a television console with a tiny black-and-white screen. These were the same movies my father had seen on the rare occasion he went to a movie as a young boy. The best part of watching those movies with my dad was that I got to know Sparky, Alfalfa, Buckwheat, Chubby and the rest of the gang, just as he had done years before. One common theme in many of those shows was "The Club." Most of us, either in our childhood or in our adult life, have belonged to some group or organization. I belong to several, some patriotic, some social, some fraternal and one just for fun. But no matter how formal or informal the organization, they all seem to have rules and regulations. I have among my papers the "charter" of a young boys' secret club. The boys wanted the club to be such a secret that on the opening page of the club documents, the club name appears as follows: "The secret order of the _____." The club membership roll and rules followed. These papers were penned by my late friend, Tommy Brookes (Thomas R. Brookes of Emmorton, Maryland, the former manager of the town of Bel Air and a humble, decorated veteran of World War II), when he was nine years old.

The first formal records of the Carroll's Island Ducking Club that survive are handwritten pages containing the by-laws, minutes, lease agreements and accounts, which are preserved on microfilm at the Baltimore County Public Library.

CARROLL'S ISLAND

DUCKING CLUB.

J. HANSON THOMAS, *President.*

ENOCH PRATT, *Treasurer.*

SAMUEL K. GEORGE, *Secretary.*

DAVID STUART.

EDWARD F. JENKINS.

RICHARD SEWELL.

JOHN H. DUVALL.

HENRY M. BASH.

WM. F. DALRYMPLE.

GEORGE TIFFANY.

SAMUEL G. WYMAN.

N. G. PENNIMAN.

J. W. OSBORN.

RICHARD NORRIS, JR.

Chas Ridgely

ARTICLES OF ASSOCIATION.

I. This Association shall be known as the "CARROLL'S ISLAND DUCKING CLUB;" shall consist of not more than fifteen members, and members to be admitted, shall be elected by ballot—two negative votes to defeat the election of any applicant.

II. The officers shall consist of a President, a Secretary, and a Treasurer, to be elected by ballot.

III. It shall be the duty of the President to see that all the stipulations and conditions of the Lease are strictly complied with; to enforce the rules of the Club, and in conjunction with any two members, to be chosen by himself, to decide all cases of dispute, from which decision there shall be no appeal.

IV. It shall be the duty of the Secretary to notify the members of all the meetings of the Club, and of the time for the payment of their annual subscription.

V. It shall be the duty of the Treasurer to collect from the members their annual subscription, and to pay the annual rent of the Island to the Lessor, on or before the fifteenth day of October in each year.

VI. There shall be Annual Meetings of the Club, held not later than the tenth day of September in each year.

BY-LAWS.

I. Members shall draw for blinds at 9 o'clock, P. M., for the ensuing day.

II. Members shall have the privilege of inviting to the Island, during the Ducking Season, not more than one friend on any one visit, such friend (provided he be not a resident of the State of Maryland) to have the privilege of shooting from any blind not occupied by any other member.

III. No member shall fire at Ducks passing over or beyond the next blind, until the occupant of said blind has first fired,—provided he fires before they shall have entirely passed over his blind.

IV. When Ducks pass between two blinds, and the occupants of said blinds shall fire simultaneously, the side upon which the Ducks that may fall, are shot, shall decide to whom they belong,—neither member, in such case, to shoot until the Ducks are squared between the blinds.

V. When Ducks pass over the bar, obliquely, every member within whose range they may come shall be entitled to fire.

VI. No member, being on either the river or bay shore, or out of his blind, shall be permitted to fire at Ducks passing over, to the interference of any member in his blind.

VII. No member, under any circumstances, shall be permitted to shoot on the Island on Sundays.

VIII. Any member who shall fail or refuse to pay his annual subscription on or before the first day of October in each and every year, shall forfeit and pay to the Club one basket champagne and two hundred and fifty segars.

IX. The Secretary shall call a meeting of the Club at the request of any three members.

X. All questions not provided for in the Articles of Association, shall be decided by a majority of members.

XI. A list of Officers and Members, and copy of the Rules and By-Laws shall be printed and hung up at Carroll's Island.

XII. A majority of members must be present, to constitute a quorum for business.

XIII. In case any member may wish to dispose of his privilege, for a season, or the whole term of the Lease, due notice of such intention must be given the Club before the date of the annual meeting in September; and his place may be filled by a substitute, provided said substitute shall be acceptable to the Club, and subject to all its Rules and By-Laws.

J. HANSON THOMAS, President.

SAMUEL K. GEORGE, Secretary.

JOHN D. TOY, PRINTER.

The Articles of Association and By-Laws were adopted on June 9, 1851, and posted at the clubhouse. *Collection of C.A. Porter Hopkins.*

The Club Years

On April 24, 1851, a meeting of the "Leasees" of Carroll's Island was held "for the purpose of forming a Ducking Club." It is apparent from the minutes of that date that some informal club organization already existed; reference is made in the minutes to "admitting not more than five additional members" and to prospective members being willing to "join the Leasees in all the responsibilities of the lease," indicating that a lease was already in place. The records also contain a receipt executed on October 15, 1851, by William Slater to Enoch Pratt, treasurer of the Carroll's Island Ducking Club, for "one thousand dollars in full for gunning privileges for one year as per annexed lease."

At the second meeting of the club on June 9, 1851, Articles of Association and By-Laws were passed. The majority of the by-laws addressed shooting etiquette, rather than the conduct of the club's business:

By-Laws
1. Members shall draw blinds at 9 o'clock, P.M., for the ensuing day.
*2. Members shall have the privilege of inviting to the Island, during the
Ducking Season, not more than one friend on any one visit, such friend
(provided he not be a resident of the City of Baltimore) to have the privilege
of shooting from any blind not occupied by any other member.*
*3. No member shall fire at Ducks passing over or beyond the next blind,
until the occupant of said blind has first fired,—provided he fires before
they shall have entirely passed over his blind.*
*4. When ducks pass between two blinds, and the occupants shall fire
simultaneously, the side upon which the Ducks that may fall, are shot, shall
decide as to whom they belong,—neither member, in such case, to shoot until
the Ducks are squared between the blinds.*
*5. When Ducks pass over the bar, obliquely, every member within whose
range they may come shall be entitled to fire.*
*6. No member, being on either the river or bay shore, or out of his blind,
shall be permitted to fire at Ducks passing over, to the interference of any
member in his blind.*
*7. No member, under any circumstances, shall be permitted to shoot on the
Island on Sundays.*
*8. Any member who shall fail or refuse to pay his annual subscription on or
before the first day of October in each and every year, shall forfeit and pay
to the Club one basket Champagne and two hundred and fifty segars [sic].*
*9. The Secretary shall call a meeting of the Club at the request of any
three members.*
*10. All questions not provided for in the Articles of Association, shall be
decided by a majority of members.*

*11. A list of Officers and Members, and copy of the Rules and By-Laws
shall be printed and hung up at Carroll's Island.*
*12. A majority of members must be present, to constitute a quorum for
business.*
*13. In case any member may wish to dispose of his privilege, for a season,
or the whole term of the Lease, due notice of such intention must be given
the Club before the date of the annual meeting in September; and his place
may be filled by a substitute, provided said substitute shall be acceptable to
the Club, and subject to all its Rules and By-Laws.*

The officers and members for 1851–52 were prominent Baltimoreans:

J. Hanson Thomas, President
Enoch Pratt, Treasurer
Samuel K. George, Secretary

David Stuart	John H. Duvall
Edward F. Jenkins	Henry M. Bash
Richard Sewell	William F. Dalrymple
George Tiffany	Samuel G. Wyman
N.G. Penniman	J.S. Reynolds
Charles Ridgely of Hampton	Richard Norris

Duvall had been shooting at Carroll's Island since the 1830s. Hanson was a physician and banker and resided on Mount Vernon Place in what is now part of the Walters Art Gallery and is known as the Hackerman House, which he built. The majority of these sportsmen were successful members of the mercantile community and most of them, including Duvall, George, Thomas, Pratt and Tiffany, were neighbors, residing on the fashionable Mount Vernon Place and Monument Street in Baltimore City.

Membership was limited to fifteen members, although the roster changed due to the practice of allowing substitute members for a given season. By the first annual meeting in September of 1851, the membership had voted to extend the restriction against guests to exclude any resident of the state of Maryland. The annual assessment for members in that year to pay for the lease and incidentals was $83.50. The construction of the duck house and magazine in 1852 called for an addition to the annual assessment. The annual meetings took place in members' residences, counting rooms and in the "Back Room" over the Farmers and Merchants Bank. Annually a committee was appointed to visit the island and make the necessary arrangements for the coming

John Johns and Isaac T. Norris in front of the duck house and magazine in 1901. The original duck house was built by the club in 1852 and paid for by special assessment. *Collection of the Latrobe family.*

season, including the arrangement of the blinds; the repair of the blinds, boats and decoys; and ensuring sufficient accommodations for the members. Other members during this first decade were Frederick Tyson, S.N. Hyde, Joseph G. Manning, William MacDonald, Joseph Wilkens, Solomon B. Davies, Cornelius Howard, Richard Tyson, Thomas H. Morris, Thomas Winans, John Buckler, Joseph E. Dall, Homand Hoffman, Otho H. Williams, W. Key Howard, Charles Carroll, J.W. Osburn, John S. Wright, John Swan, John C. Brune, Isaac W. Tyson, Robert Gilmor Jr., Robert Lehr, Henry S. Taylor, Thomas H. Buckler, Charles Weyth. Thomas Murdoch, George W. Dobbin, Robert Dorsey, William C. Pennington, W.H. DeCourcy Wright, Taylor Hall, Anthony Kennedy and John L.F. Carnan.

Slater was apparently an astute businessman. The leases he entered into with the club did not exceed three years, and by 1859, he was receiving $1,500 annual rent for the gunning privileges on Carroll's and Philip's Islands. The club reorganized in that year, and the membership was still predominately Marylanders and included longtime members such as John

Duvall. One of the new members was Henry E. Johnston, whose father, Thomas Donaldson Johnston, had gunned at Carroll's in the 1830s. Under the new lease, Slater reserved to himself certain shooting privileges, provided the club's privileges were not interfered with by his use. Slater's responsibilities under this lease included cutting the grass on the two bars, putting the blinds in good order and caring for the decoys, boats and other property of the club. He was also to provide accommodations at the house at $1.25 per day for board, $0.50 for a horse, and to furnish the services of an "acceptable and competent man for the Exclusive use of the Club for three months in each year" for $16 per month. The last surviving minutes of these years are from 1864 and 1865 and focus on limiting the use of the island by guests of the members except upon the payment of an additional $50.

The use of the island for sport continued through the Civil War. Charles Ridgely of Hampton recorded shooting there seven times in 1862, thirteen times in 1863—when he bagged 183 ducks—and nine times in 1864, when he shot 115 ducks. Some members also used the island for other purposes. Longtime member John H. Duvall, a Southern sympathizer, indulged in blockade running and made his headquarters for a time at the island. Dr. John Hanson Thomas, the first president of the club, spent seven months early in the war imprisoned for his Southern sympathies.

William Howard Russell, a noted British newspaper correspondent of the time, was a guest of the club in October of 1861 and recorded the experience in his book, *My Diary North and South*:

> *October 28th.—Telegraphed to my friend at Baltimore that I was ready for the ducks. Started with Lamy at six o'clock for Baltimore; to Gilmore House; thence to club* [the Maryland Club, of which he was an honorary member].
> *October 29th.—At ten started for the shooting ground, Carroll's Island; my companion, Mr. Pennington, drove me in a light trap, and Mr. Taylor and Lamy came with Mr. Tucker Carroll, along with guns, &c. Along the posting road to Philadelphia...on all sides except the left, great wooded lagoons visible, swarming with ducks; boats are forbidden to fire upon the birds, which are allured by wooden decoys...Reached the duck-club-house in two hours and a half; substantial farm-house, with out-offices, on a strip of land surrounded by water; Gunpowder River, Saltpetre River, facing Chesapeake; on either side lakes and tidal water;*

The Club Years

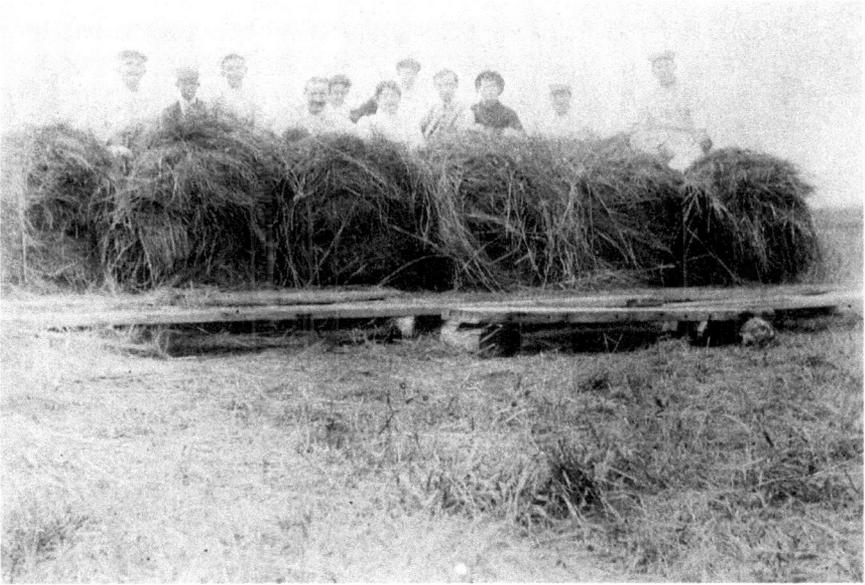

Harvest of the grass on Miller's Island. Grass was used to build blinds at both Carroll's and Miller's Islands. The 1859 lease with Colonel Slater required him to cut the grass on the bars and repair the blinds.

the owner, Slater, an Irishman, reputed very rich, selfmade. Dinner at one o'clock; any number of canvas-back ducks, plentiful joints; drink whiskey; company, Swan, Howard, Duval, Morris, and others, also extraordinary specimen named Smith, believed never to wash except in rain or by accidental sousing in the river. Went out for afternoon shooting; birds wide and high; killed seventeen; back to supper at dusk. McDonald and a guitar came over; had a negro dance; and so to bed about twelve. Lamy got single bed; I turned in with Taylor, as single beds are not permitted when the house is full.

October 30th.—A light, a grim man, and a voice in the room at four, A.M., awaken me; I am up first; breakfast; more duck, eggs, meat, mighty cakes, milk; to the gun-house, already hung with ducks, and then tramp to the "blinds"...The men in the blinds, which are square enclosures of reeds about 4½ feet high, call out "Bay," "River," according to the direction from which the ducks are coming. Down we go in blinds; they come; puffs of smoke, a bang, a volley; one bird falls with flop; another by degrees drops, and at last smites the sea; there are five down; in go the dogs. "Who shot that?" "I did." "Who killed this?" "That's Tucker's!"

39

"A good shot." "I don't know how I missed mine." Same thing again. The ducks fly prodigious heights—out of range one would think. It is exciting when the cloud does rise at first. Day voted very bad. Thence I move homeward; talk with Mr. Slater till the trap is ready; and at twelve or so, drive over to Mr. McDonald; find Lamy and Swan there; miserable shed of two-roomed shanty in a marsh; rough deal presses; whitewashed walls; fiddler in attendance; dinner of ducks and steak; whiskey, and thence to proceed to a blind or marsh, amid wooden decoys; but there is no use; no birds; high tide flooding everything; examined McDonald's stud; knocked to pieces trotting on hard ground. Rowed back to house with Mr. Pennington, and returned to mansion; all the party had but poor sport; but every one had killed something. Drew lots for bed, and won this time; Lamy, however, would not sleep double, and reposed on a hard sofa in the parlor; indications favorable for ducks. It was curious, in the early morning, to hear the incessant booming of duck-guns, along all the creeks and coves of the indented bays and salt-water marshes; and one could tell when they were fired at decoys, or were directed against birds in the air; heard a salute fired at Baltimore very distinctly.

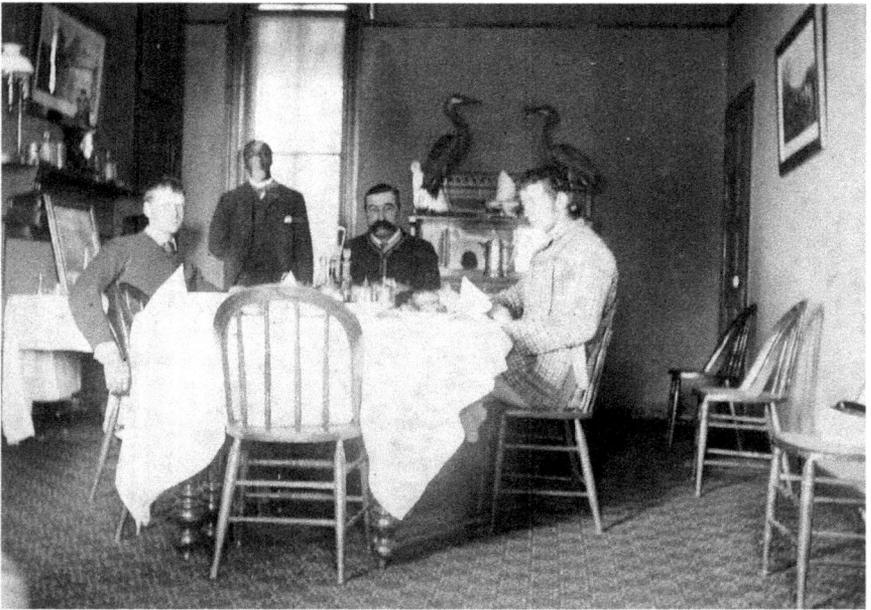

Dining room at Carroll's Island, 1886. T. Swann Latrobe, Ferdinand C. Latrobe and Thomas Swann are seated for breakfast. George Carter is standing. *Collection of the Latrobe family.*

The Club Years

October 31st.—No, no, Mr. Smith; it a'n't of no use. At four, A.M., we were invited, as usual to rise, but Taylor and I reasoned from under our respective quilts, that it would be quite as good shooting if we got up at six, and I acted in accordance with that view. Breakfasted as the sun was shining above the tree-tops, and to my blind—found there was no shooting at all—got one shot only, and killed a splendid canvas-back— on returning to home, found nearly all the party on the move—140 ducks hanging round the house, the reward of our toils, and of these I received egregious share. Drove back with Pennington, very sleepy, followed by Mr. Taylor and Lamy. I would have stayed longer if sport were better. Birds don't fly when the wind is in certain points, but lie out in great "ricks," as they are called, blackening the waters, drifting in the wind, or with wings covering their heads—poor defenseless things!...At Baltimore at 1:30—dined—Lamy resolved to stay—bade good-by to Swan and Morris. The man at first would not take my ducks and boots to register or check them—twenty-five cents did it.

General Latrobe joined the club, as he recalled, somewhere between 1865 and 1870, and he wrote of those years in his memoirs:

The dues were $100 per annum [the rent was $2,000]. *There were great quantities of ducks, geese and swan; but, the accommodations were primitive, and the distance to the blinds great. The house was the original farm house. The dining room and sitting room were small, heated by coal stoves* [Latrobe stoves]. *We slept two in a bed, in big four-posters, on feather beds. The tablefare was good, but primitive. Mrs. Slater was our landlady. The farm was a fine one, and under fair cultivation. Mrs. Slater had a large flock of fine sheep, which seemed to thrive well. The magazine, where our guns and ammunition were kept, stood in front of the house; and, on the left side of it was a big rain-water pond, in which we used to put the wing-tipped ducks. There were good dogs, and certainly plenty of ducks. We would start for the blinds before the day; having to carry our guns and ammunition & c., aided by the servants. The most of the shooting was done at the Bar, or at Whiteoak* [a decoy blind, on the Gunpowder River side], *the other points being too far distant for walking. I think it was after my first, or second year there, that we got push carts to carry our ammunition to the blinds*

The 1880s brought extensive changes both to the organization of the club and its property. After having been leased for many years, a syndicate was formed to purchase the island for $35,000 and twenty membership shares were issued at a cost of $2,500 each. By 1889, it was reported in *Forest and Stream* that Mayor Latrobe was offered $10,000 for his share by a New York gentleman. The syndicate revived the Carroll's Island Company of Baltimore County, which had been incorporated in 1856 by Slater for purposes of managing the island and the gunning and fishing rights. The majority of the membership was no longer prominent Baltimoreans; rather, New Yorkers predominated in this reorganized club. The original shareholders in 1881 were:

A. Foster Higgins, New York	Lawrence D. Alexander, New York
James C. Carter, New York	Charles C. Claghorn, New York
John G. Townsend, New York	Amos R. Little, New York
Benjamin Perkins, New York	Charles W. Middleton, New York
M. Orme Wilson, New York	Emelen Cresson, New York
John T. Metcalf, New York	Nicholas G. Penniman, Baltimore
Hermann Oelrichs, New York	Robert Garrett, Baltimore
James N. Jones, New York	J. Olney Norris, Baltimore
Charles M. Lea, New York	J. Swan Frick, Baltimore
John S. Barnes, New York	Ferdinand C. Latrobe, Baltimore

Other notable members over the next two decades were Isaac T. Norris and Theodore Marburg of Baltimore, and Ferdinand W. Roebling, Edward Floyd Jones, Charles D. Lanier and Rutherford Stuyvesant of New York.

General Latrobe described the improvements made to the property by the reorganized club:

> *An addition was built to the house; greatly improving the accommodations for the members. A new magazine was erected, and what was a great comfort, the Club had wagons built, to carry the members and their paraphernalia to the shooting points. Plenty of decoys were purchased, new blinds were built, and the old ones were fully repaired, causeways [to the offshore blinds] were built, and a liberal supply of boats were acquired. We had good dogs, well trained, and we established our now celebrated kennel of Chesapeake Bay Dogs. In other words, the Island was made a fully equipped ducking shore, or club.*

The Club Years

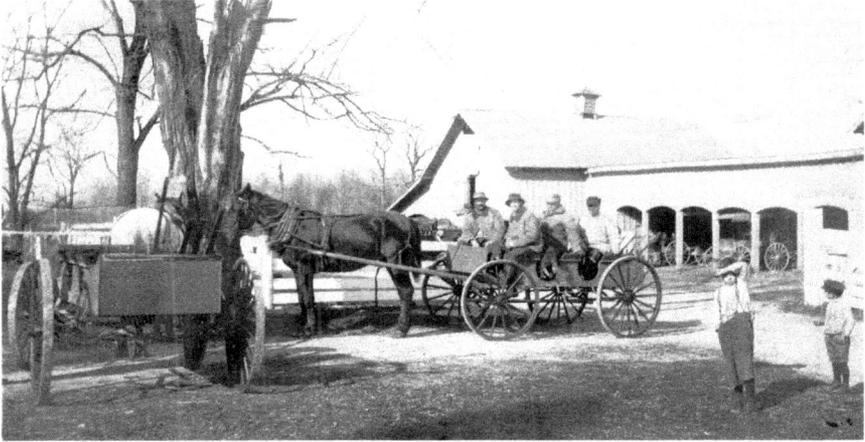

Ready to head to the blinds. In the 1880s, the club had wagons built to carry the members and their paraphernalia to the shooting points. *Collection of the Latrobe family.*

The members, who either drove down from Baltimore or arrived by train and were met by the club's carriage, arrived in the evening in time to conform with the long practiced tradition of drawing for blinds at 9:00 p.m. for the ensuing day. They were welcomed at the door by that "grand old retainer," Albert, who ushered them into the heavily red-carpeted hallway, which was kept exceptionally warm to instantly deaden the bone-chilling cold of the trip.

The words of Ferdinand C. Latrobe II captured the atmosphere of the clubhouse:

> *Upon the right, was the Locker Room, lined along the wall with those necessary containers; each filled with private stocks of liquors, cigars and tobacco. The humidors that held the latter, were kept moistened with wine…At one end of the room was a little walnut buffet, a relic of Slater's Day, where the "Men" were served their grog, upon the return from the blinds. Scattered about were several chairs…an old student lamp, and some sporting pictures finished the contents of this room.*
>
> *At the end of the hall, in the "Addition" was the Gun Room— though no guns, or ammunition were allowed in the house—or, more properly, the sitting room. It was marked by a great fireplace, wide enough to burn cordwood, surmounted with a wind-dial, operated by the weather vane atop the chimney. The motif…were sporting prints, of Bonheur style and stuffed birds—mementoes of extraordinary*

Albert, the "grand old retainer" of the club, was always on hand to greet the arriving club members who either drove down from Baltimore or arrived on the train. *Collection of the Latrobe family.*

shots, or curious species seldom seen at the Island. The floor was heavily carpeted, and covered with rugs—to deaden the squeaks of the old-fashioned leather ducking boots, and give warmth to slippered feet. Several bookcases held a heterogeneous collection of tomes… brought down for quiet reading during the winter storms, or to prove some argument. The furniture was dominated by a great round table, covered with green baize, giving room for several to sit around at one time. It was surmounted by a double-burner oil lamp, and covered with periodicals and newspapers of any age; except when it was cleared for a general game of Euchre, in which no gambling was allowed. The chairs were either those of the house committee's choice, or personal treasures thrown out by the new decorator of a member's residence. One rocker, however, was a monumental thing, built of unbarked trees, upholstered with thick basket canes, all symbolical of the might and ruggedness of the Choctaw Indians who gratefully presented it to their attorney…

The dining room was upon the left of the hall. Plain, but dignified in its furniture; and ennobled by a silver "duck press," wherein the duck's carcasses were put, to extract the "essence" as a gravy for the milk-white boiled hominy which always accompanies roast duck. This was the one room where decorum reigned, in honor of the exquisite food that weighed the table down, four times a day. Other clubs might have liveried servants, silver services and Dresden china to accompany "chef" prepared viands. But, at the Island, the black-dressed Albert, plated silver and plain white china served "Joseph's dishes"—whose flavors were beyond description, whether it be simple scrambled egg for early breakfast, the evening dinner—that Oscar of the Waldorf would have called a banquet. To our recollection, there has never been a member who was not a connoisseur, and who did not think it proper to eat royally when seeking the Royal Bird—the Canvasback. So, it was no wonder that the larder was filled with delicacies from the world over, sent down for "Joseph's cooking" by the members; to be added to the products of the Club's extensive (and expensive, too) garden, the home cured hams, the farm's lamb and mutton, the dairy's milk and the Bay's fish and crabs—all dainties that cannot be bought in stores.

Joseph's cooking was according to the true Chesapeake Bay style—no condiments were allowed to taint the natural flavor of the dish; and cabbage and onions were forbidden upon the premises. The menus were versatile, except that they always included duck, and either

The dining room at Carroll's in 1901 decorated with numerous stuffed birds—
mementos of extraordinary shots—a comfortable chaise lounge and brass spittoons.
Collection of the Latrobe family.

*Diamondback Terrapin or "Down the Bay" oysters. Vintage wines
were always served at dinner, from some member's private stock; and
the Marylander's beloved Madeira was the perfect accompaniment…*

*Upstairs, were the bedrooms, with two huge beds to each room,
plainly furnished with bureaus and chairs, and a huge chest—to hold
the bulky ducking clothes, packed in Camphor every spring, to preserve
them until the next season. In contradiction to the member's luxurious
living downstairs, and their equipment out-of-doors—the beds were
"awful," in their uncomfortableness. They were properly described,
after the one and only "Ladies day" (in 1893) by a dainty wife, who
declared the mattresses to be stuffed with cornhusks, with plenty of
cobs in the mixture. Possibly, they were especially chosen—so as not to
encourage any one to go to bed early, but to induce him to get up early.*

The day on the island began at nine o'clock in the evening, when,
according to the by-laws, the blinds were drawn for the next day. The
factotum appeared in the Gun Room, and a discussion of the weather, the

shooting on surrounding shores and the condition of the dogs took place. The wind dial on the fireplace was observed and, if the moon was bright, a member would go up to the captain's walk atop the house and scan the waters to see where the ducks had bedded down for the night. The members then drew for blinds and went to bed, laying out their ducking clothes for the next morning before retiring.

Up before dawn, the sportsmen had a modest breakfast of eggs, bacon and toast and went out into the dark to the magazine for their guns and ammunition. They then mounted their wagons with their dogs and guns and rode off to the blinds. By nine o'clock in the morning, the best of the day's shooting was over, and they returned to the clubhouse to relax or to prepare to return to their offices in Baltimore. Those who were able to linger had a nip at the buffet in the Locker Room and awaited their second breakfast, served at noon. Latrobe fondly remembered this "light repast," which began with buckwheat cakes and homemade sausage, accompanied by old-fashioned black-strap molasses. The meal continued with porterhouse steak, creamed potatoes and homemade hot rolls or corned beef hash, and concluded with Joseph's famous apple pie. By late afternoon, everyone was back in the blinds to get in what shooting they could from the evening flights.

As the years passed, the membership changed. Following the turn of the century up to 1917, Baltimoreans again predominated and there were few active members from elsewhere. The membership in 1912 included seventeen men: M. Orme Wilson, J. Olney Norris, William Carpender, Isaac T. Norris, Theodore Marburg, Charles R. Flint, Charles D. Lanier, E.H. Floyd-Jones, Daniel Bacon, J. Sanford Barnes, S. Davies Warfield, Charles C. Macgill, J.H. Wheelwright, S.R. Bertron, Samuel McRoberts, John B. Dennis and William A. House, in addition to the Estate of W.C. Whitney and the Estate of Rutherford Stuyvesant. But the long-established traditions of the "men of long boots and long barrels" continued. As Latrobe recounted, when "from the steps of the Maryland Club word would go inside the house 'wind east,' wagons were hitched to fast trotters and they would be spinning away over the pike toward the favorite shooting ground."

THE CHESAPEAKES OF CARROLL'S ISLAND

I think we all have the need to know where we came from—who our grandparents were, where past generations lived, where our families originated and why our ancestors did what they did. In my personal experience, there were a few things that I inherited that caught my attention as a child. In addition to some wonderful memories, I inherited from my grandfathers a couple of old shotguns, a couple of old rifles and an old Colt revolver. My young mind would wonder, were these old guns really used; was someone on my family tree a soldier; was someone a hunter; was someone a target shooter? My search for this knowledge led me to many places. But the main focus of those early speculations was the path that these men followed and why they did some of the things that they did in life. My maternal grandfather was a miller—why did he and his brother move from Baltimore City to northern Harford County to run a gristmill? My research led me to my maternal great-great-grandfather, who was born in Harford County in 1812 and had gone to Baltimore City to work in a gristmill close by to what is known today as the historic President Street Railroad Station. In 1868, he purchased a mill on Broad Creek near Macton, Maryland. When his young grandsons lost their parents at an early age, he saw them finish high school and then he sent them to business college. He prepared them for lives as businessmen running their own mill in a rural county far from city life.

I was extremely fortunate as a young boy to have both grandfathers in my life, and even more fortunate to have my paternal grandfather live with

my family. He was a railroad man, the bridge and building foreman for the Maryland and Pennsylvania Railroad for over thirty-eight years. We would spend days together. He let me walk beside him as he tilled the garden; I would hold the handlebars of the lawnmower as he mowed. I thought I was helping but realize today what a patient man he was. In addition to me, Pop's constant companion was Monty, his prized Chesapeake Bay retriever. Monty was always close to Pop; whether Pop was napping in his favorite rocker, walking to the railroad station in Fallston or working outside, Monty was by his side. It never struck me until years later, but why did Pop, a railroad man who in my experience had little interest in hunting, choose a Chesapeake Bay retriever over other dogs? I never would have guessed that it would take me several decades to find the answer to that perplexing question. I had always understood that my grandfather, Robert Henry Sullivan, was of Irish ancestry. Finding that family history was a challenge. His Irish-born parents were married before they reached these shores. Michael Sullivan, his father, died when Robert was quite young. Robert and my great-grandmother, Fannie, appear on the 1880 census of Harford County, Maryland, living on the farm of Harry S. Hyde in Hall's Cross Road (now Aberdeen), a part of that great land mass known as the Bush River Neck and now a part of the Aberdeen Proving Ground. My grandfather appears on that census record as the seven-year-old "boy of the cook." Years passed by quickly, and as I was researching my last book, I discovered in the *Aegis and Intelligencer* of December 4, 1891, that Harry S. Hyde had rented out the gunning privileges on his High House Farm to a Baltimore ducking club. The *Aegis* went on to comment, "Owing to the scarcity of ducks they have not as yet had much shooting, but the prospect for sport is better. The rough, cold, weather is bringing the ducks into the narrow waters." As I read that column over and over, some things in my history started to make sense to me—the old shotguns, the loading equipment in the old smokehouse and yes, the Chesapeake Bay retriever. The Hyde family had long been associated with those great retrievers.

In 1876, Harry S. Hyde's father, Samuel N. Hyde, was showing his Chesapeake, Jim, at the Baltimore Bench Show sponsored by the American Poultry and Fanciers Association. This was the first time a class of Chesapeake Bay dogs was shown. The January 13, 1877 edition of *The Rod and Gun and American Sportsman* described the excitement surrounding their appearance: "A new and exceedingly interesting novelty at the Baltimore Exhibition was the display of Chesapeake duck dogs, a breed of surpassing excellence for the purpose for which it is used." Hyde continued to show his

The Chesapeakes "were by no means uniform in appearance," according to the judges of the 1877 Baltimore Dog Show.

Chesapeakes and, according to Latrobe, had "the largest and finest kennel in the country…[with] a record of having captured 18,000 ducks over the past thirty years." Hyde owned gunning shores in Harford County on the Bush River Neck and in Baltimore County on Back River. His Baltimore County property was known as Hyde Park. In the 1850s and 1860s, he was a member of the Carroll's Island Club.

Even as the Hydes continued to show their Chesapeakes, a debate was taking place over the true Chesapeake type. The fifteen dogs that were exhibited at the 1877 Baltimore show "were by no means uniform in appearance, and might be called mongrels…[or] in weight, size, color, or coat, but well-authenticated accounts of the individual exploits of nearly all of them certainly entitle them to rank among the most hardy and sagacious of the canine race, and as the best retrievers of wildfowl in the world." A letter-writing campaign among the breeders of the dogs

appeared for many months in 1877 in both *Forest and Stream* and *The Rod and Gun*. A committee, composed of John Stewart Jr., J.J. Turner Jr. and O.D. Foulks, was appointed that year by the association to grade Chesapeake Bay dogs and establish the standards for the breed, setting forth the proper size, colors and other characteristics. The Maryland Poultry and Fanciers' Association adopted the committee's recommendation of three classes of Chesapeake Bay dogs: "First—The otter dog, class otter. Second—The curly hair dog, class curly. Third—The straight hair dog, class straight." One member of the Carroll's Island Club, John Stewart, served on that committee. His Chesapeake, Turk, took first place in the Chesapeake Bay Duck Dogs or Bitches at the 1877 show, according to the January 11, 1877 issue of *Forest and Stream*.

Most readers of this work will recall the story of the origin of the breed. In 1807, an English brig capsized with two Newfoundlands onboard, a dog Sailor and a bitch Canton. Sailor went to Mr. John Mercer of West River, and Canton went to Dr. James Stewart of Sparrow's Point. The two rescued pups were crossed with native stock, and the Chesapeake breed was born. This story was first related in J.S. Skinner's book, *The Dog and the Sportsman*, published in 1845.

The Carroll's Island club dogs' lineage can be traced to Canton and Sailor through John Stewart's dog, Turk, the champion at the 1877 show. Turk's line was authenticated by Dr. W.H. Keener, another breeder who exhibited at the 1877 show. Turk's daughter Belle, who was owned by John Ridgley of Hampton, was bred to General Latrobe's stud, Grover C. Cleveland. Cleveland came from the Walnut Grove stock—Walnut Grove, the estate of Thomas Jones, adjoined Dr. James Stewart's Sparrow's Point, the home of Canton. The offspring of Belle and Cleveland, Duck, won the second-place prize at the 1890 Baltimore Dog Show. Duck was owned by J. Swan Frick, who was a member of Carroll's Island Club, as was John Ridgely of Hampton, Belle's owner.

In 1836, Tyrone Power in his book, *Impressions of America*, recorded his observation of these dogs during a visit to Carroll's Island. On October 27, 1834, his journal entry describes the dogs at work: "Half a dozen Retrievers, of a mixed breed, lay lounging on the grass in front of this line of watchboxes, awaiting the moment when work should be cut out for their Sagacities. These were admirably trained to their vocation, as I had an opportunity of judging while a looker-on here."

His description of the Chesapeakes in action is probably the earliest in print describing the Chesapeake at work:

The Chesapeakes of Carroll's Island

On the occasion of a small flight, a couple of long shots were made, and a duck winged slightly: it made a good downward slant, and fell forty yards from the shore into the Seneca: at the same moment in dashed four dogs after it, halter-skelter: there was a little sea on, and the object of their search at first unseen by them: a wave of the hand from the sportsman was the signal by which their line was regulated, and for this one of the four would occasionally look back. The wounded bird, on being neared, dived, followed by the foremost dog; the others staunchly pursuing the line of their under-course, directed by the air-bubbles rising to the surface: in a little time, up came the duck ahead of its pursuers, and the dog close upon it; being hard pressed, down again went the duck, and down went another dog; and for several times this was repeated, until the case was nearly a mile from the beach, when the dogs were recalled from a pursuit which is rarely successful unless the game has received some bodily wound, or has a limb broken,—so active and strong are these birds in the water.

John Stuart Skinner, who was Power's companion, erased any doubt that Power was describing Chesapeakes—years later his account of that same day was published in *Reminiscences of An Old Sportsman*, describing the dogs as being "of that noble and unique breed unrivalled in all the world as retrievers, known in my day as Carroll's Island dogs, but which are now registered on the show benches as Chesapeake Bay dogs."

In an interview with Ambassador J. Fife Symington Jr. and T. Edward Hambleton Jr., his cousin, whose family members were principals of the

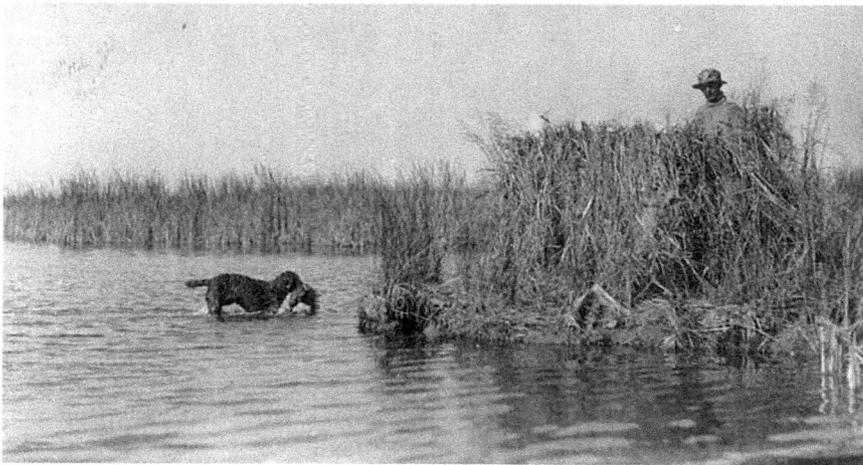

A noble Chesapeake making a retrieve to a blind in Hawk Cove. *Collection of the Latrobe family.*

Grace's Quarter Gunning Club, they spoke of the sagacity of the dogs of the kennel there.

> *We learned by age twelve* [in the early 1920s] *to watch the dogs because they would sense the ducks minutes before we could see or hear them. We would watch those yellow eyes and their heads as they sensed a flock heading our way. They would sit behind the blind with their backs pushed up against the grasses. When we shot the ducks, they would jump into the Gunpowder to retrieve. If there were cripples, they would dive after them. Those ducks would go under, and the dogs would dive for them. Those ducks stayed under so long it was as if they were holding onto the grasses on the bottom.*

The Latrobe history suggests that the island was most proud of the line that began 1886 with the famous Chesapeakes, Dan and Jeannie, because this blood presented the best working dogs. The line culminated in 1901, with the great-great-grandson Jack No. 3, whose mother, Gill,

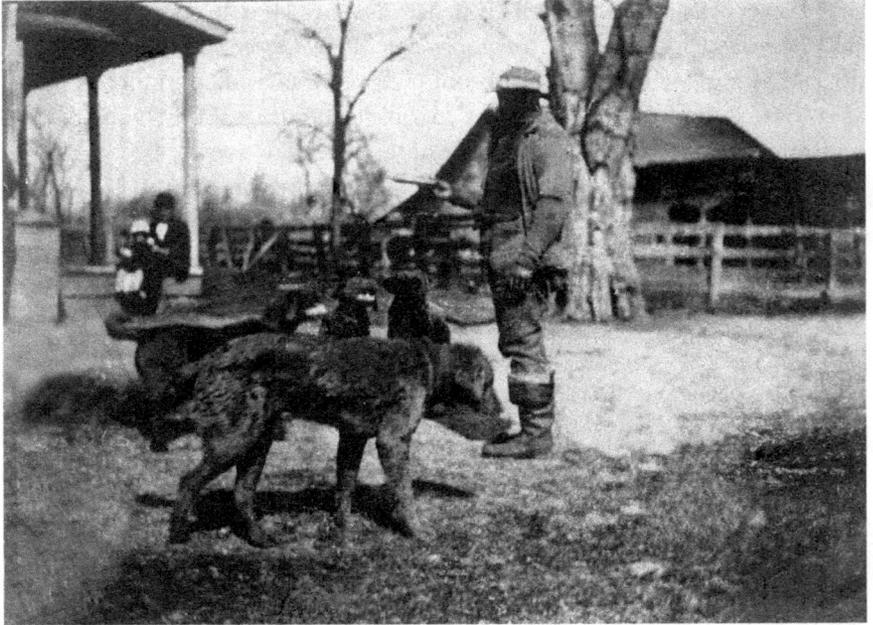

John Johns with some of the Carroll's Island Chesapeakes. General Latrobe attributed John Johns with bringing to the island the Chesapeake Dan, the great sire of the Carroll's Island stock. *Collection of the Latrobe family.*

born in 1893, was descended on both sides of her parentage from Dan and Jeannie. Although it is widely believed that all of the Carroll's Island breeding records were lost as a result of a disastrous fire at the club in the early years of the twentieth century, General Latrobe maintained a studbook for Carroll's Island from 1883 to 1908. It remains in the possession of his family.

General Latrobe recorded in his personal studbook:

> DAN. *The great sire of Carroll's Island stock…John Johns, one of the attendants, was going along the Philadelphia turnpike, about 1881, when he met the wagon of Mr. Williams, on the road. Tied behind the wagon was a thin, distressed looking dog of the Chesapeake Bay kind, dirty and muddy. To an enquiry of what he intended "doing with that dog?" the man replied that he was going to take him up the turnpike somewhere, and lose him. The dog had come to him astray, he didn't want to kill him, so he was going to lose him. John requested him to give to him, John, the dog, which he willing did. John brought the dog to the Island and gave him to Mr. J.S. Frick, as a substitute for a dog of Mr. Frick's which he, John, had lost. He was poor and miserable looking, half starved, and his teeth all worn down from gnawing bones. Mr. Frick named him DANIEL; (certainly he looked as if he came from a lion's den). He became really a landmark on the Island. Great intelligence, great endurance, and, when thoroughly trained, no wind or ice stopped his pursuit of a duck; and he knew all the dodges for catching a crippled fowl. In the latter part of his life, he lost an ear in a battle—but was as good as ever. DAN is dead [1888], "Requiescat in pace."*

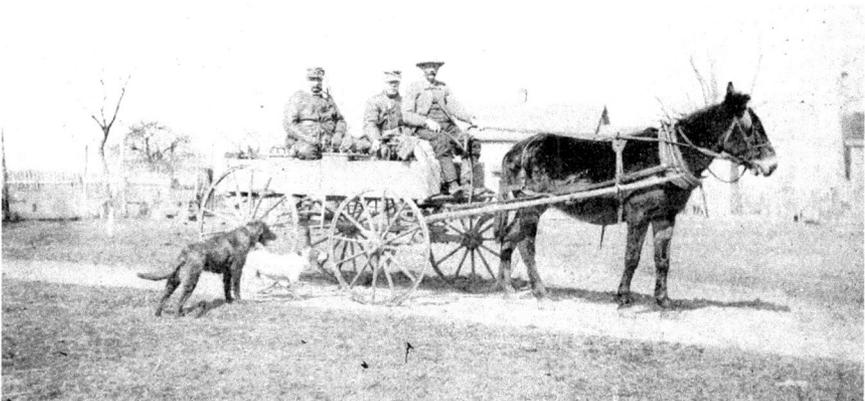

Ferdinand Latrobe, William Winchester and Jack in 1901. Jack's sire was a Marshy Point dog. *Collection of the Latrobe family.*

Sport came to the island in 1901. He was bought from Helldorfer, the saloonkeeper at Middle River. He was said to be of Mallory's stock. Sport died in the summer of 1907. "He was a very fine dog and died after long and valuable service." *Collection of the Latrobe family.*

His reminiscences also describe the other dogs in this line:

> CHAMP [the sire of Jeannie], *was a large yellow dog, stout, well built, and a fine fighter. He was brought to the Island by me.* Lady [the dam of Jeannie] *pupped in 1880. She was a fine dog, and was given to me, during one of* [my] *Mayoralties, by Mr. Hamlin, Keeper of the Dog Pound, and an old ducker. She was a large curly-coated bitch, much lighter in color than our characteristic liver-colored dogs; and she helped impress upon her progeny the sedge, or marsh-grass color, we were seeking. She did good work for many years, and was a prominent ancestress of our celebrated kennel.*

Dan and Jeannie were the parents of Jim and Turk. Latrobe described Turk:

> TURK [broken, as were the majority of the dogs, by Mr. Ferdinand W. Roebling], *was very much like old <u>Dan</u>, and was one of the best dogs ever on the Island. A beautiful specimen of the breed, he was immortalized by an artist, Tracy, who visited the Island, and painted*

56

The Chesapeakes of Carroll's Island

"That noble and unique breed unrivalled in all the world as retrievers, known as the Carroll's Island dog," or in General Latrobe's words, "just a dog." *Collection of the Latrobe family.*

One of the best dogs ever on the island. *Collection of the Latrobe family.*

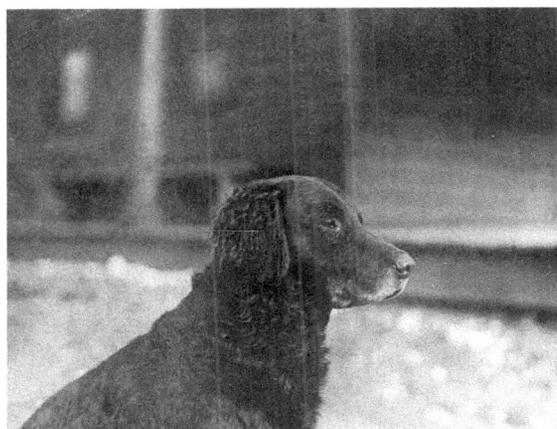

Requiescat in pace. *Collection of the Latrobe family.*

him in an oil painting—retrieving a goose. <u>Grace</u>, belonged to Mr. John S. Gittings. Her sire was a dog belonging to Mr. Frederick May, and one of the best of the Eastern Shore type. Her dam was the Lego Point strain, bred by Dr. W.H. Keener, whose dogs were the old "Rose" strain. Their descendent was <u>Fritz</u>, a remarkably well built, strong, active, quick and good retriever, on land as well as from the water. He has many of the characteristics of his grandsire <u>Dan</u>. He has a wonderful nose, and will wind a wounded, or dead duck in the marshes a long distance. One morning, he found a goose in the marsh, shot dead the evening before by Mr. Wilson, and given up for lost. Out of doors, he is loyal, true and brave. In the house, he is dignified and quiet, asking recognition as a gentledog, of good family and breeding, his behavior is without reproach.

Turk was apparently the only dog allowed in the clubhouse. Turk was bred with Grace and their offspring was a large, yellow, short-haired dog named Fritz.

Jim, the full brother to Turk, was given to Dr. Charles Tilghman on the Wye River, near Easton. He was bred with Beauty, who was owned by Mr. Hooper of Havre de Grace. Their offspring, Joan, "was a liver-color, without a white mark on her. Her coat was like that of an Otter. She was first class in every way." Fritz and Joan were bred to produce Gill, Gill was bred to a Marshy Point dog and the surviving pup from that litter was Jack No. 3. In 1904, Jack No. 3 was bred to Fannie, a bitch of unknown pedigree, belonging to Joshua Wilkinson, the club's factotum, and the litter produced Jeff, Jennie, Dan, Lou and Rose. These dogs all remained on Carroll's Island.

General Latrobe's studbook also reveals that Carroll's Island dogs were bred with dogs from Marshy Point, Maxwell's Point, Grace's Quarter, Miller's Island and virtually all of the gunning shores of the Chesapeake. Ferdinand W. Roebling, a club member from New York, broke the majority of the dogs used on the island in the latter part of the nineteenth century. Other Carroll's Island dogs were scattered afar—to the kennels of the Swan Island Club at Currituck, North Carolina, to San Francisco with Hermann Oelrichs and to a Mrs. Elizabeth Lennox of Brooklyn, New York.

Perhaps one of the greatest treasures among General Latrobe's records is this studbook of the Carroll's Island dogs that he kept, commencing in 1883 and concluding in 1908. The contents of this record are set forth in Appendix I to this book.

SHOOTING METHODS AT CARROLL'S ISLAND

It is impossible for modern-day waterfowlers or devotees of sport shooting to imagine some of the methods and techniques employed by waterfowlers of the early 1880s through the early 1900s. The types of firearms used, the quantity of waterfowl available and the numerous hunting grounds enjoyed by the earliest Chesapeake Bay gunners determined these methods and techniques. Readers will recall the descriptive words used by Captain John Smith relating the multitudes of wildfowl present when he first arrived in the Chesapeake region in 1607: "There are swans, cranes, geese and ducks aplenty." But his often quoted words fail to capture the extent of the bounty as well as the words of some who followed him. The observations of early settlers and visitors to Maryland were summarized in the December 2003 Public Comment Response of the North American Gamebird Association to proposed regulations by the U.S. Fish & Wildlife Service regarding captive-reared mallards:

> Marylander George Alsop wrote in 1666 that in early September on the Chesapeake Bay ducks "arrive in the millionous multitudes" and "beleaguer the borders of the shore with their winged dragoons." His flowery prose might suggest poetic exaggeration. But Robert Evelyn, a fellow Marylander of the same era, witnessed a single flight of ducks at the head of the bay that he estimated to be a mile wide and seven miles long. And Henry Danckaert in 1680 came upon a Chesapeake Bay cove so tightly packed with ducks the resting flock resembled "a mass of filth or turf."

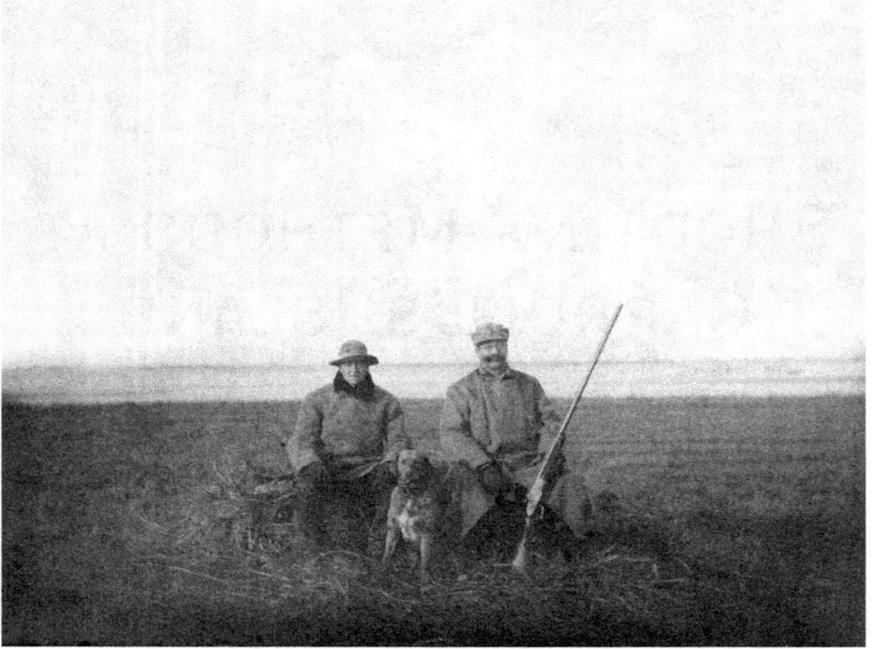

Blind No. 3, Carroll's Island Bar—F.C. Latrobe, Thomas Swann and bitch Jennie in 1886. *Collection of the Latrobe family.*

Given those quantities of wildfowl, it was much less of a sporting enterprise for our earliest settlers to shoot a duck, goose or swan for a meal. The technical advancements to early fowling pieces limited the shooters to a single-barrel, muzzleloading flintlock gun. There was one shot with such a fowling piece, and if the shooter missed on his first shot, the time taken to reload would be a missed opportunity until the fowl would return. There is little doubt that, for many years, wildfowl were shot while resting or feeding. It is highly unlikely that these early Americans thought of waterfowling as a sport. But by 1819, gunning clubs had been formed and many in the Chesapeake region were enjoying shooting for sport. Many of the earliest sportsmen were wealthy city dwellers who formed clubs and traveled to nearby waterfront locales for the great sport afforded by the presence of vast flocks of wildfowl. With these changes came changes in firearms and changes in the shooting methods employed to harvest the wildfowl.

According to George Grinnell, "In old times this [Carroll's Island] was the heart of the best shooting in the Chesapeake Bay." Of all the varieties

of shooting, the method that brought great fame to Carroll's Island was bar shooting. A "bar" is defined in George J. Manson's *The Sporting Dictionary* as "a shoal under water." Carroll's Island possessed two bars: the "Bar," a very long, narrow peninsula that ran far out into the mouth of the Gunpowder River, and "Lower Island," which extended into the mouth of Middle River. The two bars jutted out into the bay, forming a V-shaped cove known as Bay Cove. Bay Cove, a great feeding and bedding ground, was protected from time immemorial by the club rules. The cove offered to the waterfowl a sanctuary to be gotten into or out of over the Bar, if the birds wished to trade to and from the Gunpowder, or over Lower Island, if they wished to go or come from Middle River or Seneca Creek. The gunning method for bar shooting, also known as pass shooting, involved the shooter holding his gun in an almost perpendicular position to shoot the fowl as they passed overhead.

In *The Dead Shot*, Marksman described the difficulty of and the skill required for these perpendicular shots:

> *A great deal must depend on the altitude at which the bird is flying; but in general, these shots are missed through firing too soon, or too late: the one as the bird approaches, the other after it passed overhead. If sportsmen could only consider and practice a few perpendicular shots, they would find none are easier: there is plenty of time for deliberation when the bird is seen approaching. The instant it comes nearly over your head, lean back, take a good aim, and fire several inches in front, according to the speed or rate of its flight, and you are certain to kill: whereas, by firing at the breast as the bird approaches, if your shot strike, they probably glide off the feathers without penetration through the skin; and by waiting until the bird has passed, you lose your very best chance; because, independently of the greater accuracy of the aim, you lose the additional effect produced by the bird being at an acute angle with the shot. By shooting perpendicularly, you have also the chance of a second shot in the event of missing the first.*

George Grinnell said this of Carroll's Island bar shooting:

> *Often for a time there was no decoy shooting, and all ducks secured were killed from the bar which runs out into the Gunpowder River from the island.*
> *The shooting on the bar was at ducks flying from the bay to the Gunpowder River, and originally was done from blinds in the rushes on*

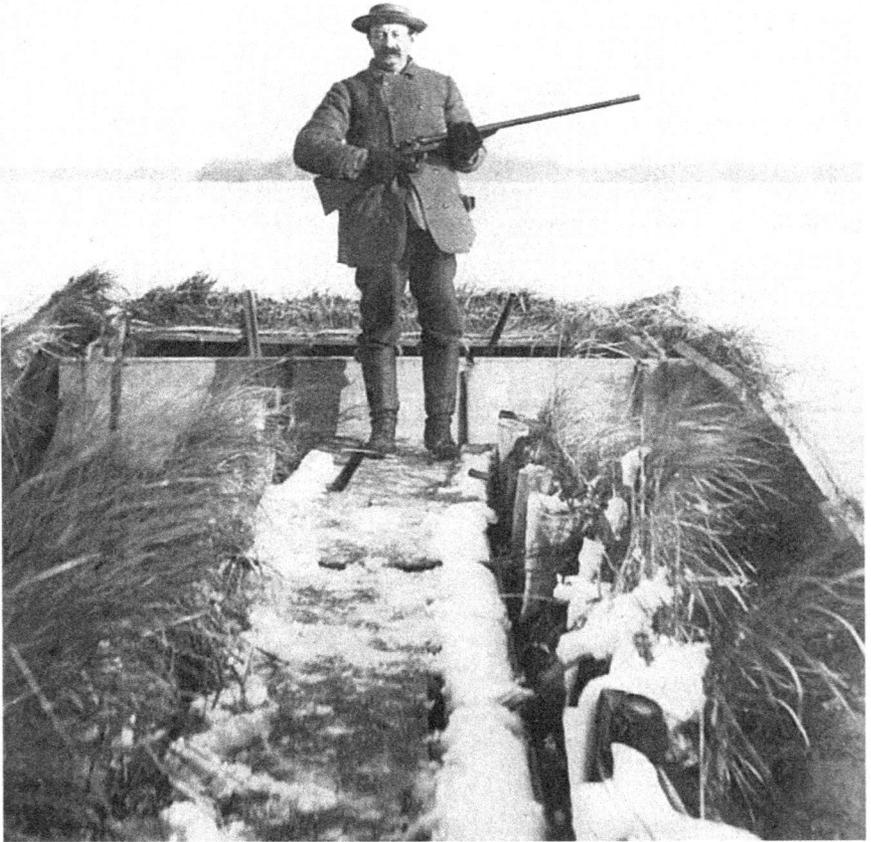

Josh Wilkinson standing in a box on the famous Bar. The barrels of two large-bore shotguns protrude behind him. *Collection of the Latrobe family.*

the bar. Later, boxes were sunk in the bar, from which the men did their shooting…Often when the ducks flew well there was great shooting here, which in its character was precisely like the pass shooting, elsewhere described. The birds came overhead, at greater or less height, according to the weather, and were shot as they flew over. As is elsewhere stated, the shooting at these overhead birds, which began with comparatively small guns, came at last to be done with very heavy No. 4 gauge weapons, in which enormous charges of No. 2 and No. 3 shot were used.

Shooting Methods at Carroll's Island

Both John Stuart Skinner and Tyrone Power described the shooting boxes referred to by Grinnell as they appeared in October of 1834, when the two shot together on the Bar at Carroll's Island. Power wrote in his journal that fall:

> We walked down on to the long neck of land where the shooters patiently abide the flight of the ducks: on one side is the Seneca, and on the other the Gunpowder: both favorite feeding-grounds of all the water-fowl frequenting this region of creeks, rivers, and bays. About the central line of the neck of land, a dozen or so stands are ranged at equal distances, built about four feet high, each large enough for two gunners; with shelves within for the various traps needful, a plank floor, and a couple of stools.

Skinner likewise described those boxes, as they were that day:

> These stands, it may be as well to explain, are uncovered boxes, about five feet square, stretching along, nearly a dozen in number, on a long narrow strip of land called the "bar," which divides the bay from the Gunpowder River, and over which at certain times the fowl pass in incredible numbers. In favorable weather they fly low and within easy range of the boxes, which are about a gunshot apart.
> …The boxes on the bar are provided with a bench at either end, one serving as a seat, the other to hold the ammunition ready for rapid loading. These boxes, about shoulder-high, afford good shelter from the cutting winds to which the bar is, of course, exposed.

The other shooting method practiced on Carroll's Island was "point shooting." The island had numerous gunning points, among them Lower Island, Weir, White Oak, Schultz and Stubby. As Skinner noted, "When the wind does not favor shooting from the bar, and often from choice, some of the sportsmen prefer shooting over the decoys, for which the undented shore line of the Island, twenty miles in extent, affords the very best opportunities." Elisha J. Lewis described the ideal circumstances as when the weather was not intensely cold and the wind was blowing from a quarter that carried the ducks toward the point. Point shooting required the use of blinds built along the shores from the native grasses, brush and driftwood or, as on Carroll's Island, "boxes sunk in the marsh, each furnished with a pump for the removal of any water which leaked in to the box, and provided with seats, and with

shelves in front, on which to rest ammunition." On occasion, decoys were used. Less difficult than the perpendicular shooting required out on the bar, Elisha J. Lewis explained that nevertheless "great skill and judgment are requisite to strike the Ducks; and when thus suddenly stopped in their rapid course, they present a beautiful sight as they come tumbling down with a heavy plash from a height of one, two, or even three hundred feet." Grinnell opined, "No form of duck shooting is more pleasing and none more artistic" and "when the weather is favorable, no form offers greater rewards."

Shooting methods at any time or place have much to do with the success of the shoot. Although comfort takes some place in this preference, the ultimate goal is the sport provided. In the December 16, 1876 issue of *The Rod and Gun and American Sportsman*, a correspondent wrote that on December 4 of that year 163 ducks had been killed on the bar at Carroll's Island. The editor went on to comment on Carroll's, noting that "it is the most valuable sporting estate we ever saw—has no less than twenty-two miles of shore line, and is in the very center of the canvass-back shooting grounds." He described the shooting over decoys and the bar shooting at the island: "The bar shooting we believe is held to be the nobler sport of the two, as it requires more skill than the other, and heavier guns are necessary." But he concluded that he did not like it, preferring to forgo the bruised shoulder and headache.

Today's waterfowlers enjoy comfort and amenities while enjoying their sport, unlike any dreamed of during the days of Carroll's Island. Even so, the sport enjoyed at Carroll's, regardless of the gunning method employed, was beyond the comprehension of modern-day waterfowlers.

1. My first Carroll's Island branded decoy.

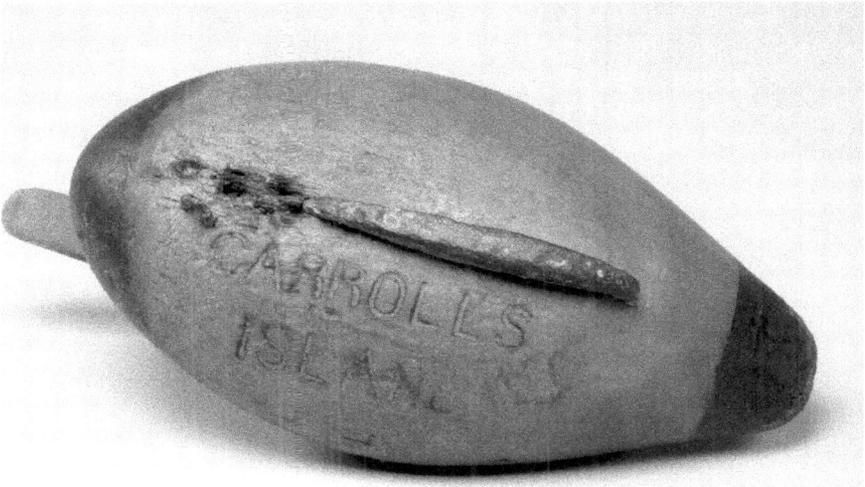

2. Redhead drake by James T. Holly, wearing cast-iron ballast weight and branded with the Carroll's Island brand.

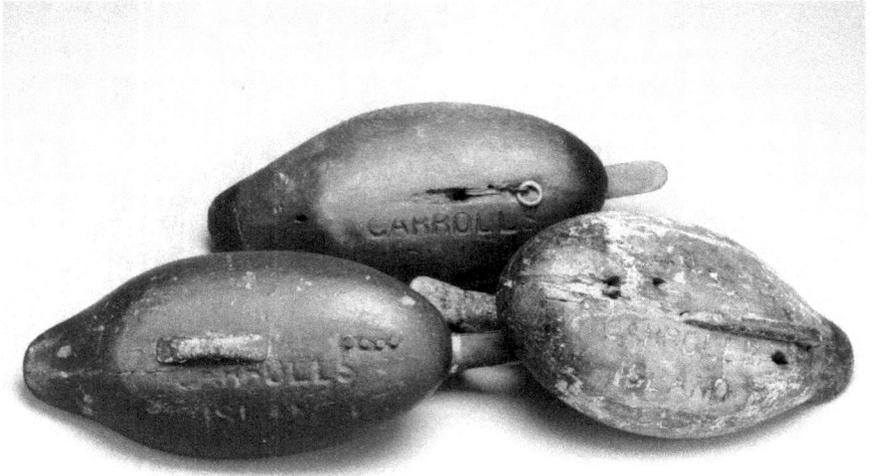

3. Three Carroll's Island Club branded decoys, each carved by James T. Holly of Havre de Grace, circa 1860.

4. Redhead pair by James T. Holly, Havre de Grace, circa 1870. The drake wears a cast-iron ballast weight. The decoys are branded Carroll's Island.

5. Redhead hens by James T. Holly, Havre de Grace, circa 1870. The front decoy is branded E. Thorne, a Long Island gunner. The rear decoy is branded Carroll's Island.

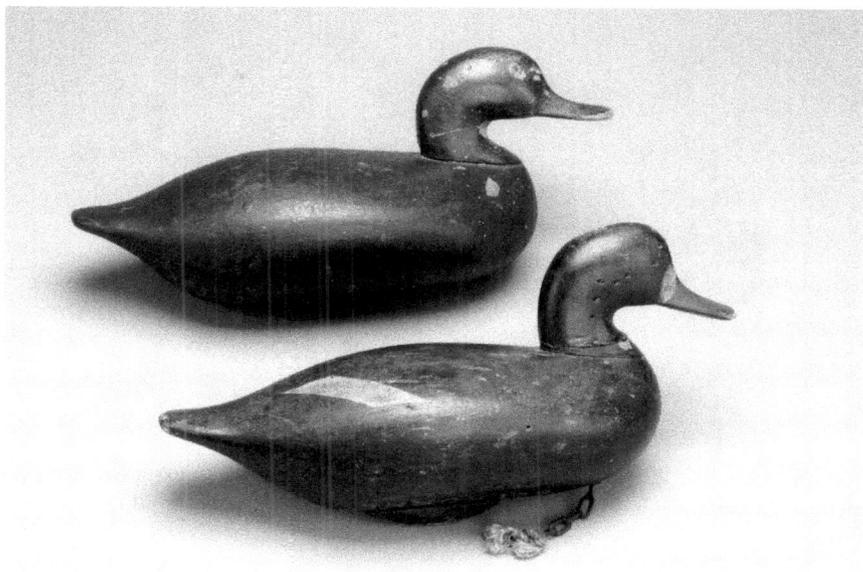

6. Redhead hens by James T. Holly, Havre de Grace, circa 1870. E. Thorne brand and Carroll's Island brand.

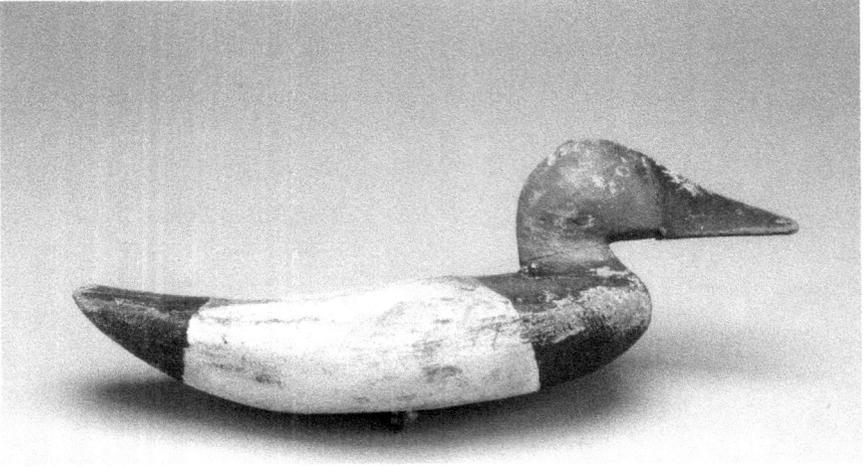

7. Canvasback drake by Edmund Hardcastle, Easton, Maryland, circa 1900. Hardcastle was a guest of member Hughlett Hardcastle at Carroll's Island in 1904.

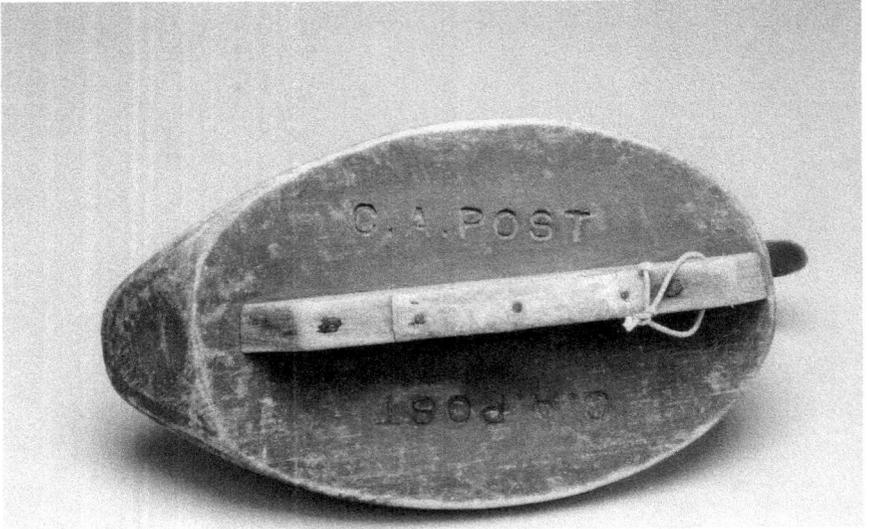

8. Canvasback hen, maker unknown, Long Island, New York, branded C.A. Post, a member of the Spesutia Island Rod and Gun Club and the Carroll's Island Ducking Club.

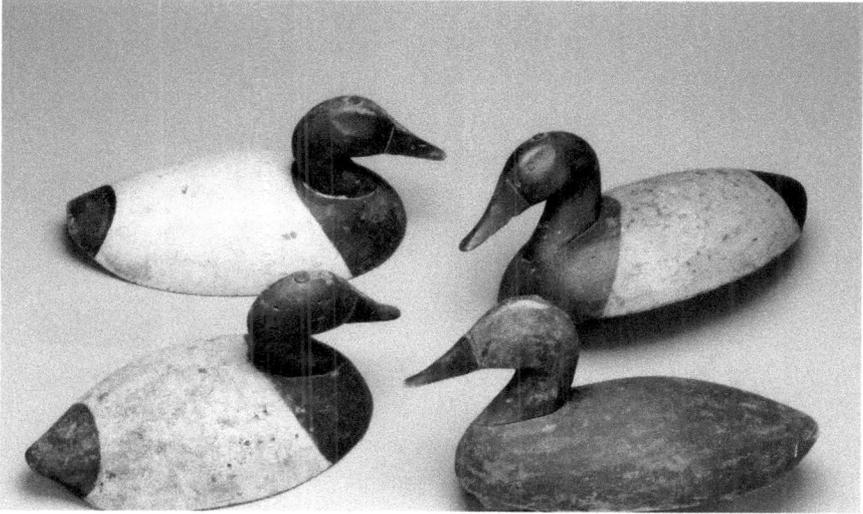

9. Group of canvasbacks, carved on Long Island and used at Spesutia and Carroll's Islands.

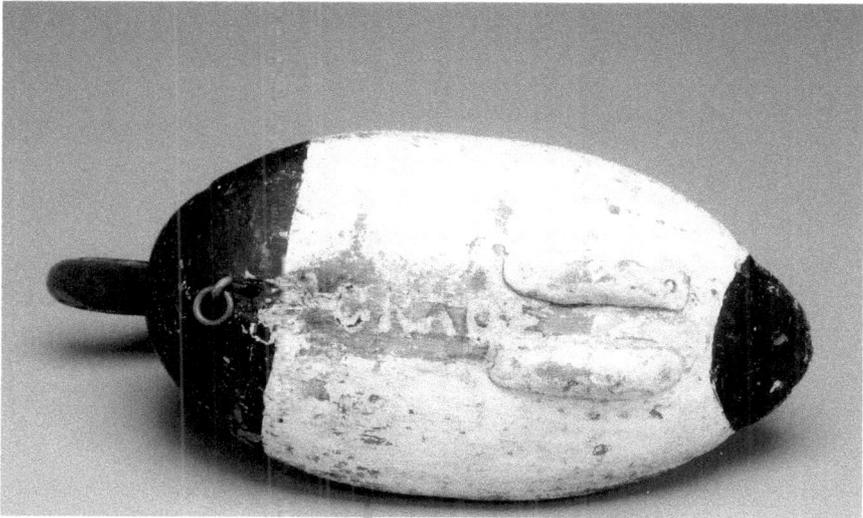

10. Canvasback drake by John B. Graham, Charlestown, circa 1870, branded Grace and used at the Grace's Quarter Gunning Club.

11. Canvasback drake by James T. Holly, Havre de Grace, circa 1870. This decoy wears the brand of J.D. Mallory, a member of the Board of Governors of the Chesapeake Bay Dog Club.

12. Bluebill drake by James T. Holly, Havre de Grace, circa 1870, branded RSDFC for Charles Raymond of the San Domingo Farm Club on the Gunpowder River.

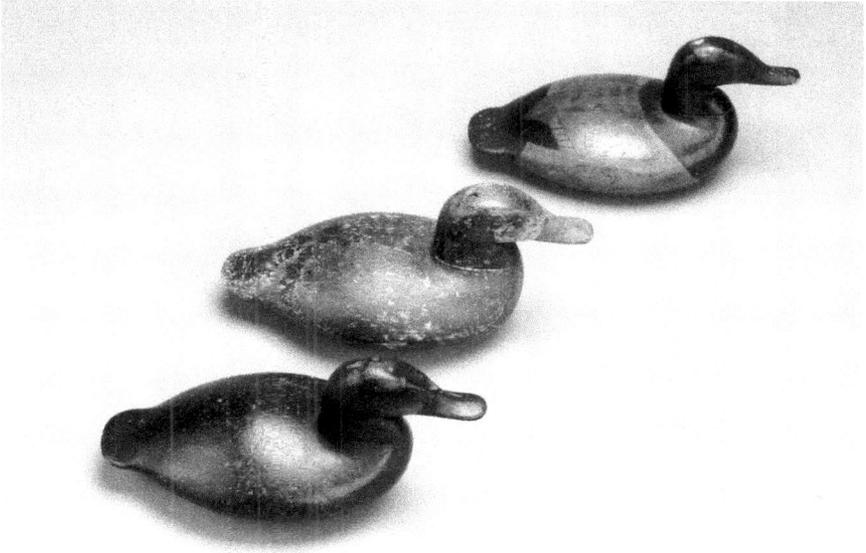

13. Ruddy ducks by Captain Benjamin Dye, Charlestown, Maryland, circa 1854.

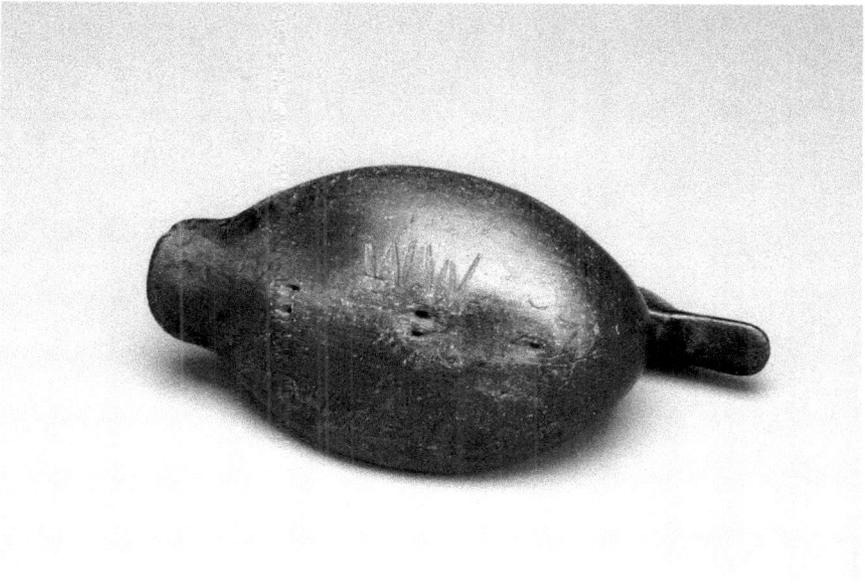

14. Ruddy duck wearing WW on its underside. Williams Williams was a member of the Marshy Point Ducking Club in 1854.

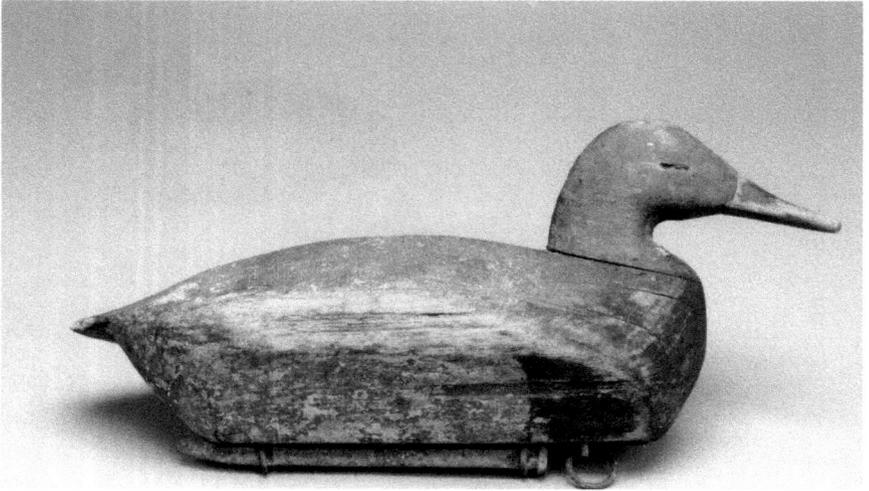

15. Redhead drake, maker unknown, found at Bowley's Quarters, circa 1860.

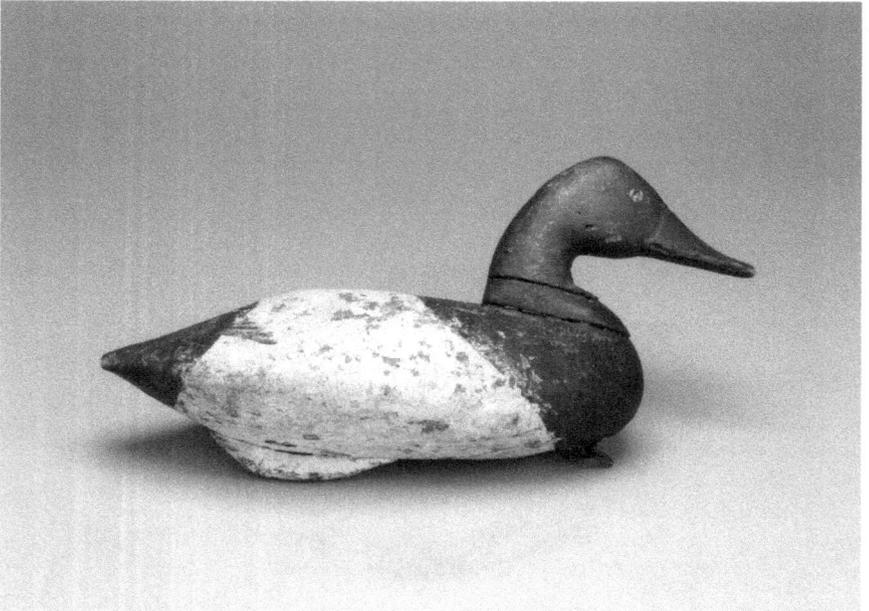

16. Canvasback drake by John B. Graham, Charlestown, circa 1850.

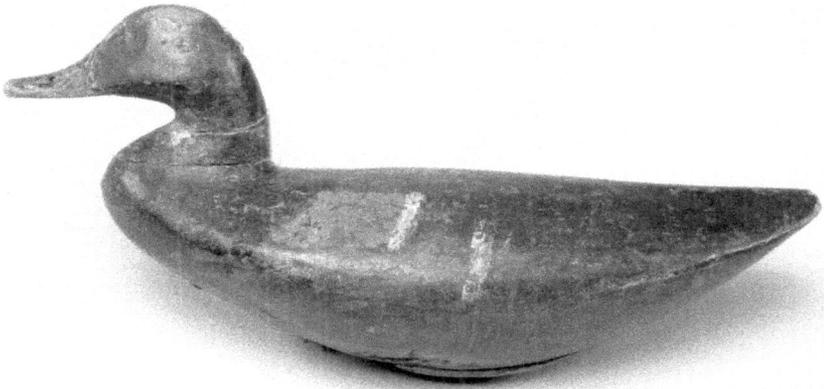

17. Blue wing teal by Charles T. Wilson, Havre de Grace, circa 1870.

18. Swan pair, maker unknown, full-size decoys, circa 1880, of the type used at Carroll's and Miller's Islands.

19. Baldpate drakes by James T. Holly, Havre de Grace, circa 1870. The front bird traveled to Long Island, New York; the rear bird stayed on Carroll's Island.

20. Bufflehead pair, maker unknown, circa 1870, used near Carroll's Island at Bowley's Quarters.

21. Mallard pair by James T. Holly, circa 1870, found in a boathouse on Carroll's Island Road.

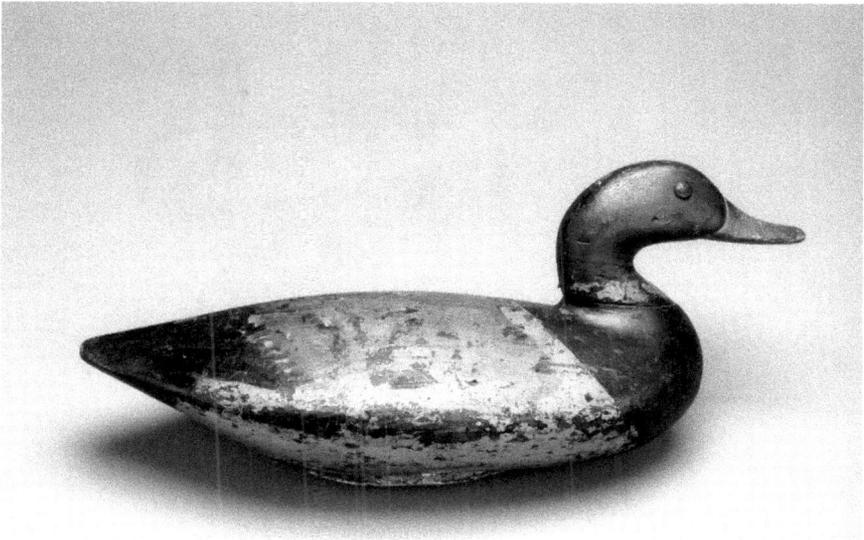

22. Mallard drake by John B. Graham, Charlestown, Maryland, circa 1870.

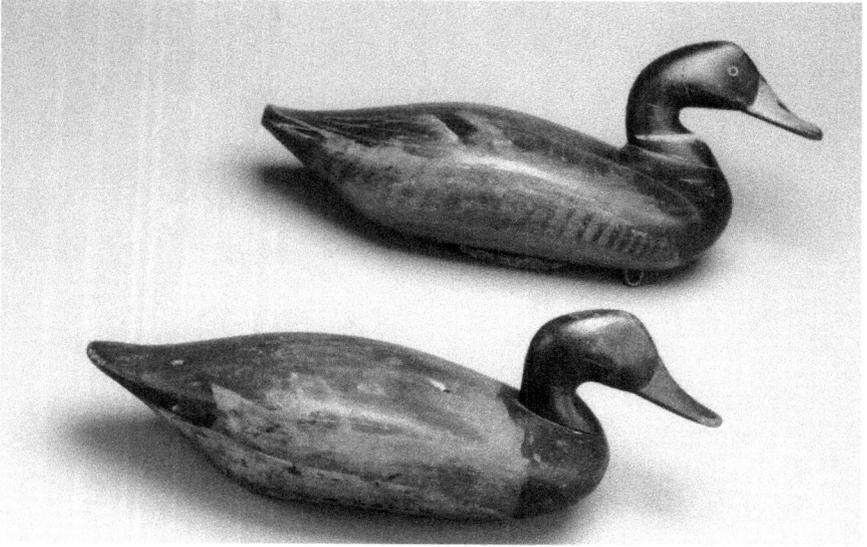

23. Mallard drakes by James T. Holly, Havre de Grace, circa 1870. These mallards traveled from Havre de Grace to Long Island and back to Carroll's Island.

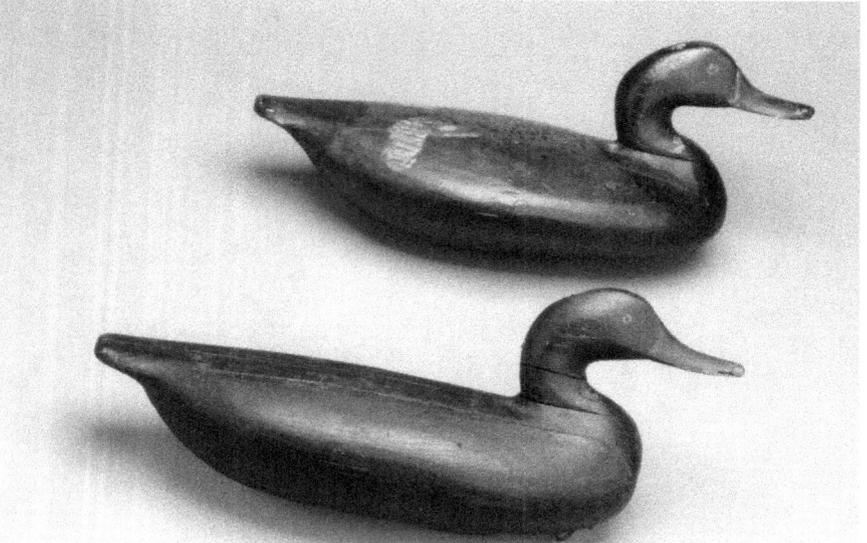

24. Blackduck pair by James T. Holly, Havre de Grace, circa 1880. Used at Carroll's Island.

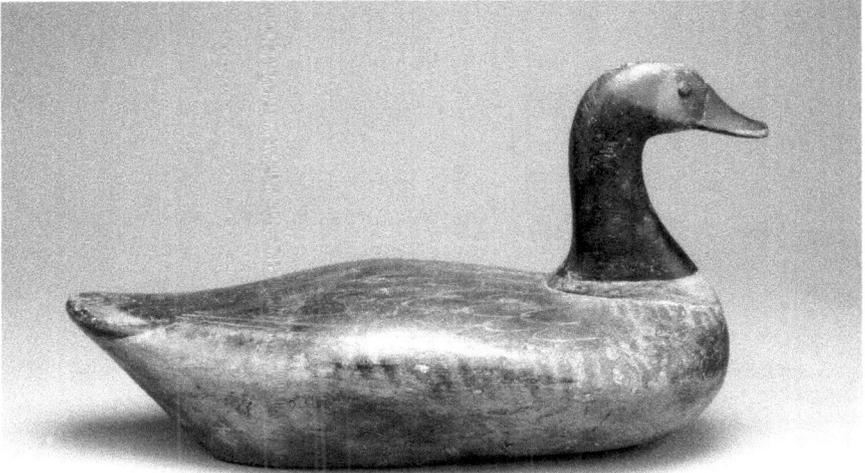

25. Canada goose by James T. Holly, Havre de Grace, circa 1890.

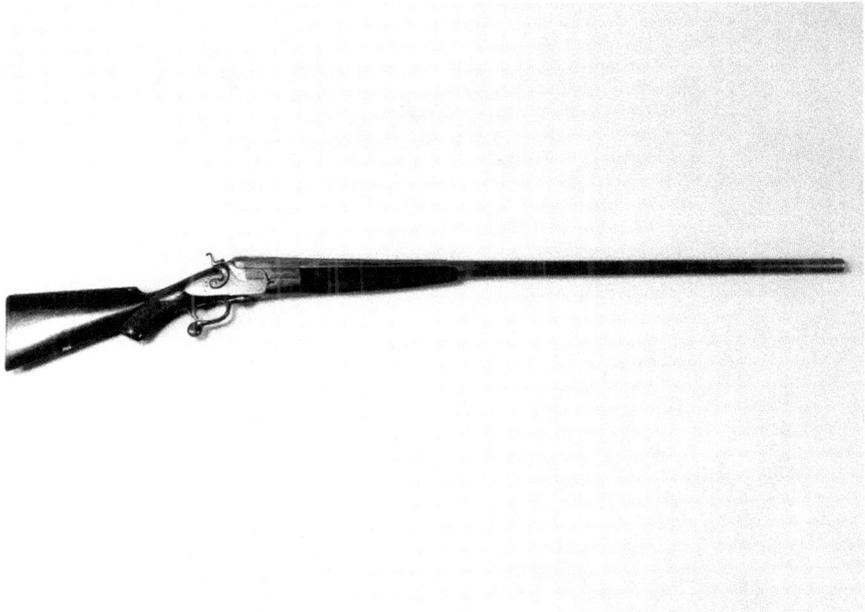

26. Four-gauge single-barrel breech-loading under lever shotgun, Clark and Sneider, Baltimore, Maryland. This gun was purchased by DeLancey Floyd Jones of Long Island, New York, and was used by him on Carroll's Island.

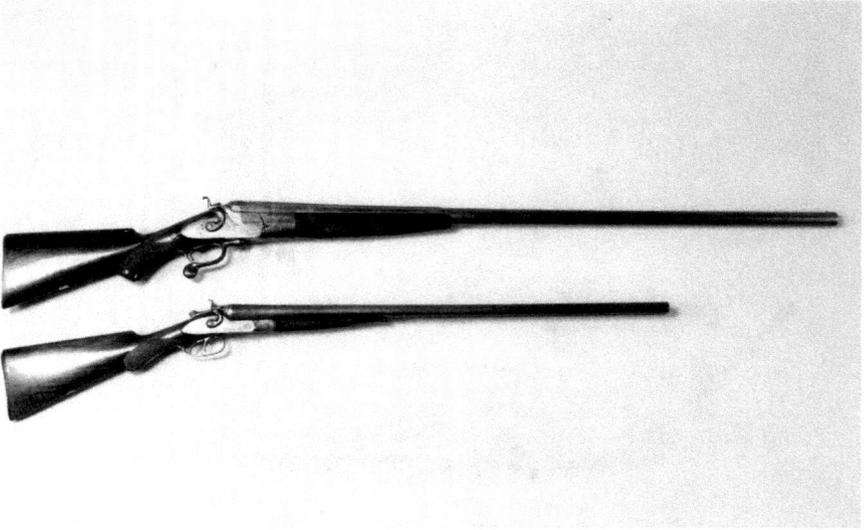

27. The top gun is a four-gauge Clark and Sneider, bottom gun a ten-gauge double-barrel breachloader top lever by Clark and Sneider.

28. DeLancey Floyd Jones's four-gauge shell carrier.

29. *Right:* Interior of D. Floyd Jones's shell carrier showing twenty-five four-gauge shells and a Merchants Shot Works shot bag.

30. *Below:* Four-gauge single-barrel muzzleloading shotgun, Alexander McComas, 51 South Calvert Street, Baltimore, Maryland, circa 1860.

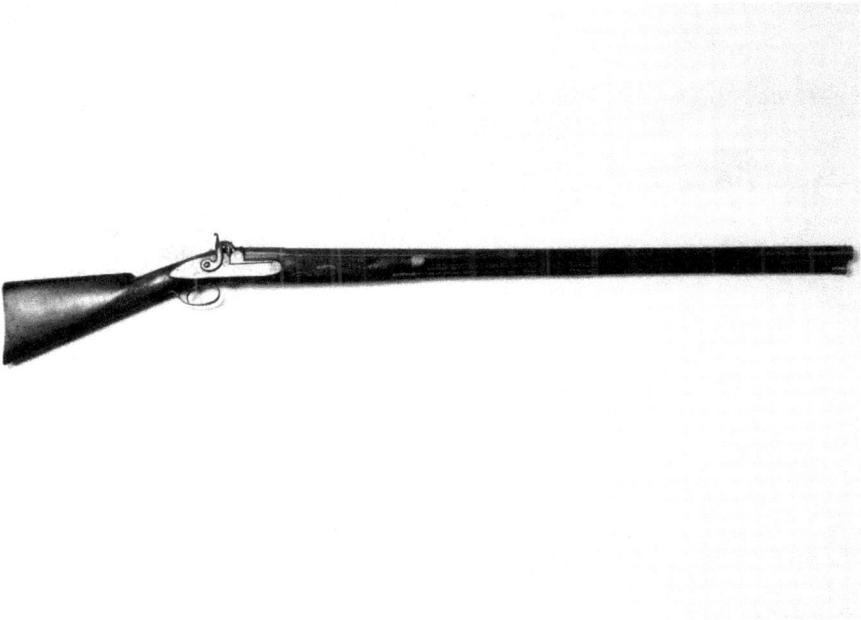

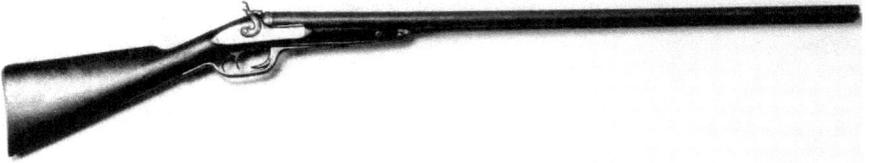

31. Eight-gauge double-barrel shotgun by Alexander McComas. Formerly muzzleloading, converted to breech-loading by Clark and Sneider circa 1878. The price for conversion was advertised in their catalogue of 1878 as seventy-five dollars.

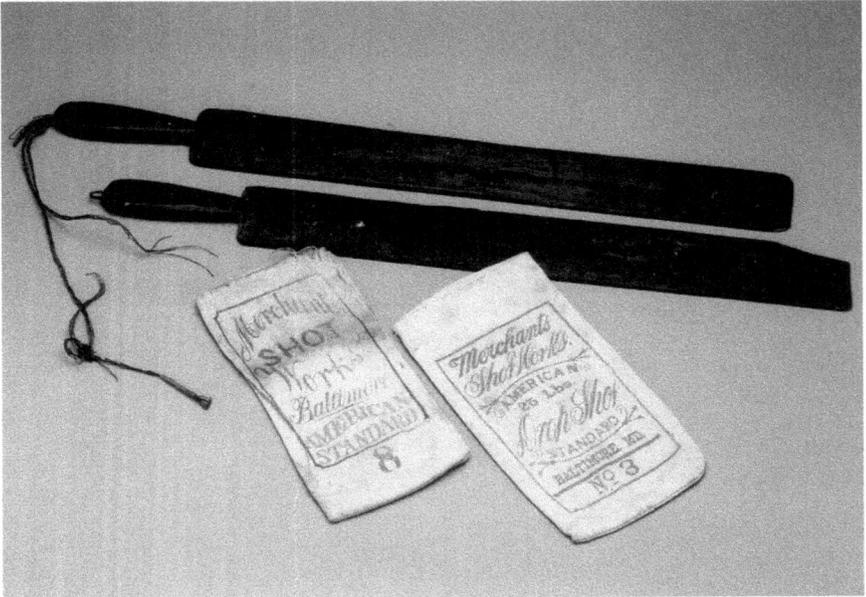

32. Night gunning paddles used on the Bush and Gunpowder Rivers.

BIG BOYS, BIG GUNS

I, along with millions of young boys, grew up holding a fascination with guns. I will never know if growing up in a household with a few old guns or watching cowboy shows and movies was the cause of my interest. I inherited the guns of my grandfathers and my father. My father, his father and my aunt gave me my safety instructions with firearms when I was old enough to shoot. I took great pride in having a gun rack in my bedroom before my teenage years. One of the guns on that rack was a ten-gauge Remington shotgun. It was a single-barrel side cocker (Serial No. 62212) with a thirty-two-inch barrel. My young friends who visited my room were amazed at the size of that shotgun. I never fired it, out of respect for its age and the knowledge of the damage it could do to me or whatever I tried to hit with it. That old gun became an inspiration for me as I became a regular at the local gun shows. I was always on the lookout for large-bore shotguns. The Harford County Chapter of the Isaak Walton League sponsored a gun show at the American Legion Post in Bel Air. It was an interesting little show, with the Legion members mixing with hard-core gun collectors and dealers. It was a great opportunity for a young collector to visit the old-timers, and from time to time I could purchase a decent old decoy, an old Baltimore shot bag or a large-bore shot shell to satisfy my passion. In the mid-1960s at the Baltimore Antique Arms Collector Show, I purchased my very first eight-gauge double-barrel. That first eight-bore was an English gun from the shop of Manton in London.

The eight-gauge guns were much scarcer than the ten-gauges. Years later, while still proud of my grandfather's ten-gauge, I read a comment that General Latrobe made in reference to a shotgun of that size being used at Carroll's Island. He referred to the ten-gauge shotguns as "those popguns."

By 1964, I had access to the Bar Library in the Harford County Courthouse and began my research of the earliest waterfowling laws. I can remember the anticipation I felt sitting among those high, dusty old shelves and pulling down those historic tomes. I would scan the indexes and tables of contents for the topics of firearms, waterfowl, gunning and hunting. The earliest volumes had been moved from the library to the attic of the courthouse. I also had access to that wonderful and historic place and would sit in the great oak Windsor armchairs that once held jurors in the days when they were all male and were required to spend the night in the courthouse if their deliberations were unfinished. I discovered in the 1859 volume of *The Revised Laws of the State of Maryland* that "no person shall shoot, or shoot at any wild fowl in the waters of Cecil, Kent, Queen Anne's, Harford or Baltimore counties, or in Wye river or its tributaries, by night, from any skiff, float or other boat, with a gun of any description whatever, nor in the day time from any skiff, float or other boat, with

Confiscated and disarmed punt gunstocks, locks removed and barrels cut. A single night gunner's paddle rests beside them. *Collection of the Latrobe family.*

Big Boys, Big Guns

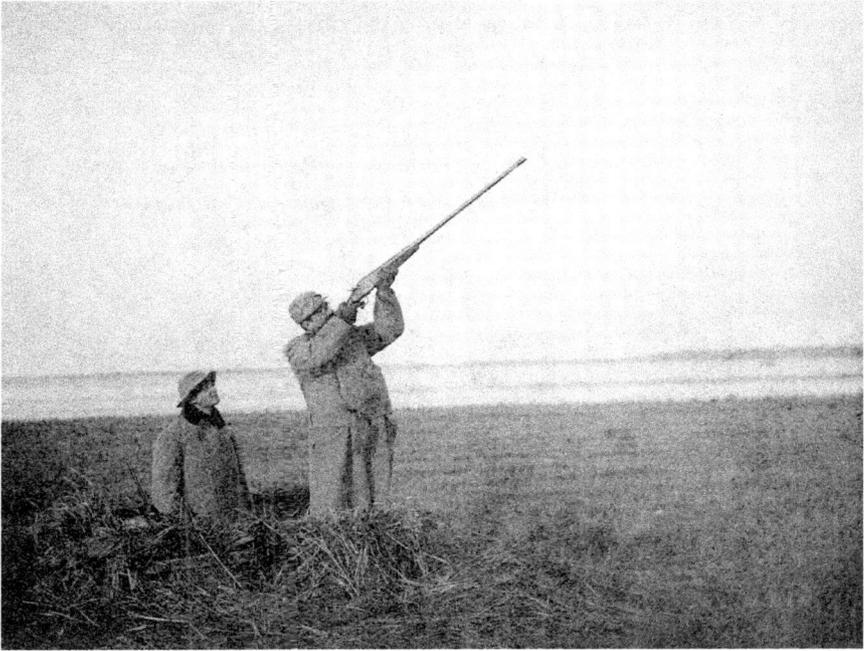

Blind No. 3, Carroll's Island Bar—Ferdinand Latrobe takes aim with his four-gauge under lever shotgun. Thomas Swann and the bitch Jennie accompany him. *Collection of the Latrobe family.*

any gun which cannot conveniently be discharged from the shoulder at arms' length without rest," a law that had been in effect as early as 1832. The Migratory Bird Treaty Act of 1918 required that only guns not larger than ten-gauge could be used to take birds. For the reader unfamiliar with guns, the larger guns with larger bores are those with the lower gauge numbers. Thus, four-, six- and eight-gauge shotguns were outlawed.

I had always thought the large-bore guns gave the gunner a better chance of killing waterfowl. I did not understand the gunning methods used along the rivers and islands of the upper Chesapeake Bay. While the gunners on the Susquehanna Flats had employed the use of the sinkbox as a primary means of killing waterfowl, the fowlers that shot ducks, geese and swan on the bars and points that jutted into the rivers feeding the bay employed a completely different means of shooting. These gunners relied on overhead shots that required larger-bore guns than the closer-in shots from a sinkbox, bushwhack boat or blind.

As the years passed, my fascination with the use of large-bore fowling pieces grew. In the Game Book of the Carroll's Island Ducking Club, a note was written at the end of the season of 1884–85:

> *The number of canvasbacks killed was small, the largest bag being made at the Spring by Mr. Frick 30. There were very few black heads killed—the baldpates spring shooting was comparatively a failure owing to the short spring season a great many Geese and swan were about the Island especially in the Spring...*
>
> *The number of ducks about the Island was about the same as last season although the flying was higher as the ducks gradually recognize the necessity for getting beyond the range of the big guns—The shooting on bar and lower island was good whenever the ducks were about.*
>
> <div align="right">

J. Swan Frick
Secretary
April 12ᵗʰ 1885
Record shows 2,604 head of game
</div>

These large-bore guns were used all along the coastline of the bay and its tributaries. In his book, *There Are No Dull Dark Days*, Percy Thayer

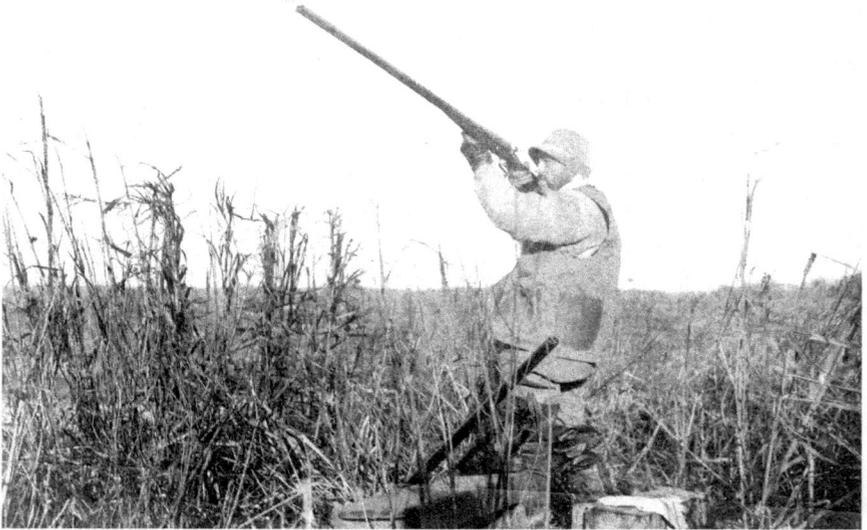

Charles R. Flint shooting one of his large-bore double barrels at the Devils Wood Yard, Lower Island. *Collection of the Latrobe family.*

Big Boys, Big Guns

Blogg recalled shooting at the Miller's Island Ducking Club in the early 1900s. He wrote that at Miller's Island "there were two 4-gauge guns which belonged to the club and which were used by members for swan and goose shooting, the shells contained 12 drams of black powder and as much no. 2 shot as could be crammed into them. It was astonishing to note at what distance 'Big Liz' could pull a swan or goose out of the air." Years later, when Percy Thayer Blogg's personal photograph album came into my possession, among the early shooting photographs were sketches of the early club members at Miller's. Below the image of Blogg was his nickname, "Big Gun Blogg."

It was the Bar at Carroll's that brought the greatest fame to the island. It was the oldest stand or shooting location. Because it required overhead shooting at birds "flying like meteors across the narrow neck," only those who could shoot the "Big Guns" patronized it.

Ferdinand Latrobe recorded details of the use of four-gauge guns in his history:

> We well remember the delight of Mr. J. Olney Norris, when he brought to the Island, in 1909, from Richmond the last available 25 pounds of the essential "Double Eagle" powder, with the remark—"That, will let us shoot on the Bar during our lifetime." A prophecy that was only too true, as the little group of "No. 4 gun men" was soon so quickly dispersed, that half of the canister of the powder was inherited by the next generation very soon thereafter.
>
> That the No. 4 gun had a good "kick" to it, cannot be denied. The secret in the art of handling them, however, was a simple one—namely, to shoot them overhead, that the gunner's entire frame, from his shoulder to his feet, was in line with the gun—to absorb the recoil. To shoot them in the horizontal position, would turn the gunner over instantly. Mr. Norris, a small, "stocky man," as broad as he was long, learnt that fact in one lesson at Currituck, where he decided to "try-out" his No. 4 gun, over decoys, from a sitting sink-box. A beautiful bunch of Canvasback came in, low to the water—up came the No. 4, pointed a little downward. "Bang" went the gun, and "bang" went Mr. Norris through the back of the box, which he took with him! On the other hand, General Latrobe, who stood over six feet, and weighed 250 pounds, wrote in his diary, in March 1896,—"A regular snowstorm. Floyd Jones, 'Ty' Norris, and myself went to the Bar. A great many ducks. I shot my No. 4 over 50 times. Shot very badly. Got 30 ducks. A lot

got away." All of those shots took place between dawn and 9 o'clock [a.m.], when he started back to Baltimore.

If anything, the jarring of these big guns, and the exposure, preferably to snow or sleet, on the Bar, was a healthy occupation. The suggestion of the corps of "No. 4 gun men" at Carroll's Island lasted for nearly 90 years. "Uncle" John H. Duvall, shot upon the Bar, from the 1820s to the 1880s; "Johannes Cygnus," or John Swan, from the 1830s to 1890s; "Uncle" Nicholas G. Penniman, from the 1840s to 1890s; Ferdinand C. Latrobe, from 1870s to 1910s, as did his contemporaries, J. Swan Frick and "Pos," or J. Olney Norris. Their persistent devotion to the big guns, and the Bar, was delightfully portrayed by General Latrobe's entry in his diary, upon the occasion of his youngest son's introduction to the guild of duckers, who he took to Whiteoak, to shoot over decoys;—"Got nothing Shot at a lot of Swan, in the afternoon. Too high. Guns too small!"

While many of the early sporting books made reference to the use of the large-bore shotguns for shooting over the bars, Ferdinand Latrobe best expressed the changes that made the use of the large-bore guns necessary:

The fame of Carroll's Island had evidently extended, too, to the duck tribe, who were learning the dangers of crossing the Bar, and the

"Pos" Norris with an eight-bore in hand and another at the ready. *Collection of the Latrobe family.*

range of the 10 gauge guns that laid in wait for them. So, they were commencing to cross higher in the air, and the gunners were finding that they needed a longer-range piece to reach their game. In the beginning, 10 gauge and the 9 gauge guns were used for ducking; which, with 4-½ drams of black powder and 1-³/₈ ounces of shot, gave a good pattern at 80 yards, with good penetration. Later, in decoy shooting, the 8 gauge gun came into use, which with 7 drams of powder and 2-½ ounces of shot, gave a good pattern and penetration, at 100 yards. Before the appearance of the latter gun, there appeared for Bar, or overhead shooting, the 6 gauge, which, with 9 drams of powder and 2 ounces of shot, gave a good pattern and excellent penetration at 100 yards.

Latrobe went on to quote Frank Forrester (the pen name of William Henry Herbert, the prolific writer of sporting books), from what appears to be an advertising endorsement, on his choice of a hunting gun:

Forrester, in 1866, told of his gun, and its obvious inspiration from the Bar shooting at the Island;—"I have just learned that D.B. Trimble, Sportsman's Warehouse, 200 Baltimore street, has a fine lot of ducking guns of Wesley Richard's [a famous gunsmith] *best, made to the order of the Carroll's Island pattern, nearly similar to the guns recommended by me. These guns are of the best laminated steel. Barrels, 45 inches; 6 gauge; will chamber 22 BB shot; weight of barrels, 8 pounds; of stock 7-½ pounds; of entire gun 15-½ pounds…price, complete, $112. Mr. Trimble has guns of the same style by other makers, $75. I have no hesitation in recommending the 112 dollar Wesley Richard's piece, as the best style of shoulder duck-gun in the World, and very cheap at the price. Guns of this fashion, and nearly of this size, were recommended by me, in 1850, to some gentlemen in Baltimore, to whom I showed one of the same kind, but somewhat larger, previous to the time, they had not, I believe, been used in that section of the country."*

Latrobe continued:

Though the "No. 4" gauge gun is a little ahead of the chronological story, but, as what we have now to say concerns all of the guns, we may as well follow Benjamin Franklin and "say Grace over the barrel of herring, once and for all!" The 4 gauge gun came to use about 1880, when the ducks had climbed still higher into the sky over the Bar. Where

they looked a little bigger than a pigeon, the Goose a little bigger than the Duck, and the Swan, though exaggerated by its huge wing spread, its body looked hardly the size of a goose. To reach these birds, the 4 gauge, with 11 drams of powder and 3-½ ounces of shot, gave an excellent pattern at 100 yards, with equal penetration, and a good pattern and good penetration at 130 yards. It must be remembered, however, that the above tests were made with breechloading (cartridge) guns; whereas, the preference for the muzzle loader laid in the advantage of being able to vary the load with the shooting. Mr. Nicholas G. Penniman, and Mr. J. Swan Frick, famous shots at the Island, both used 6 gauge guns; and the former's huge powder charger and multi-pocketed leather shot pouch are well recollected. It was the custom, to prognosticate the probable heights of the flights of the Bar; taking into consideration, the weather, the activity and the performances of the ducks. Then the powder charger was set to measure more or less, according to whether the ducks were flying high or low, and the load was poured into the muzzle, with an Ely wad rammed down upon it. Then, from the pouch was selected the shot—ranging from No. 1, through BB, to 7 (the Baltimore shot tower even made 7777); and the shot charger was filled with either small shot for low flights, or the larger shot for higher flights, or still larger for the "Big game," then the charger was poured into the muzzle, another wad rammed down—and the gunner awaited his birds, with his gun always loaded agreeably to the shooting of the moment.

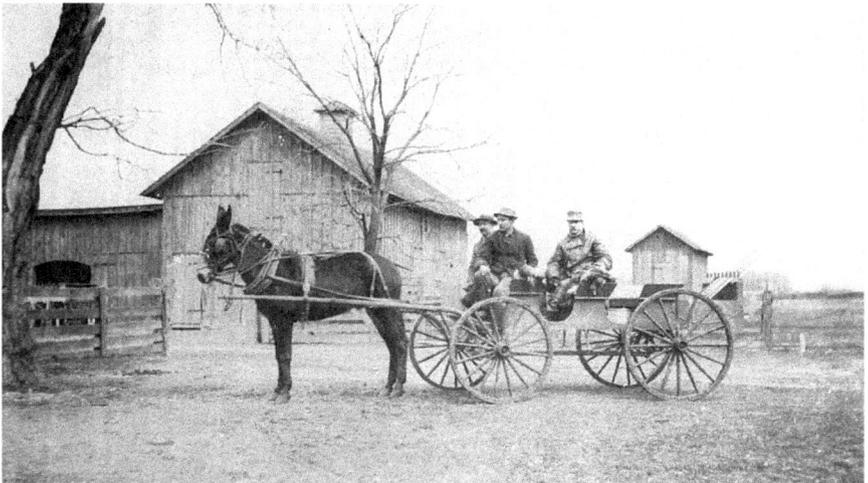

The Carroll's Island wagon with three gunners going out to the blinds with their large-bore shotguns resting in the wagon gun rack. *Collection of the Latrobe family.*

Big Boys, Big Guns

In 1985, my late friend, Mary Helen Cadwalader, called me and asked that I stop by to look at some firearms that had been used by her family and their guests at Maxwell's Point and their other gunning shores. General George Cadwalader of Philadelphia, her great-great-uncle, began purchasing land on the Gunpowder Neck in Harford County in the 1840s; he eventually owned virtually the entire neck. His property stretched to more than ten miles in length and included nearly forty miles of waterfront land. I visited Mary Helen and carried down from the attic several historic fowling pieces. I doubt that I can adequately express the pleasure that I felt that day as I dusted off those big old guns that had rested beside the family photographs and journals of days gone by. I gave my opinion and estimate of value to her and returned the guns to their resting place in the attic, where they had been since the army took their magnificent waterfront estate to build the United States Army Chemical Center in 1917. Many months passed, and I heard from Miss Cadwalader once again. This time it was like a dream come true—she asked me if I would like to own one of those historic fowling pieces. I picked a 4-gauge single-barrel marked E. Hollis with English proof marks. That gun has a forty-eight-inch barrel and weighs a hefty eighteen pounds. It is a muzzleloader and played a great part in waterfowling history. It was used by John Cadwalader and his guests to shoot the fowl that flew over the Point on his 11,000-acre estate. I recently learned that General George Cadwalader purchased two other large-bore muzzleloaders. These guns were shipped to his Philadelphia office from the renowned Purdey firm of London, one in 1840 and the other in 1841. Purdey indicated the size to be larger than 8-gauge, measuring approximately 7³⁄₄–gauge. These Purdeys had been gun room mates at Maxwell's Point to my Hollis.

In December of 2002, I received a call from an old gun collector friend of mine from Long Island, New York. He was representing the estate of a fellow collector who had recently passed away. I was offered the choice of guns from the collection. Among them was the four-gauge breechloader of Delancy Floyd Jones. Jones and his brother had both gunned at Carroll's Island. The gun, serial number 599, was manufactured specifically for Jones in Baltimore by Clark and Sneider. Accompanying it was a leather shell box with Jones's name impressed in the top holding twenty-five brass four-gauge shells. It now is a wonderful companion piece to the Cadwalader gun.

THE DECOYS OF
CARROLL'S ISLAND

My very first decoy was presented to me by my maternal grandparents. It was probably their effort to protect the pair that rested on the hearth of my parents' fireplace from my young and curious hands. That first decoy became the focal point of my childhood bedroom. It was an old and worn bird that sat on a piece of green marble on top of the radiator. One summer when my father was painting the outside shutters in that great shutter green, I took it upon myself to paint that old decoy green; after all, it would be complemented by the green marble, the green radiator and the green on the grasslands of my cowboy motif wallpaper. At about age eighteen, I covered the cowboy paper with knotty pine and stripped the green paint off that decoy. It came off easily, and the decoy quickly returned to its worn old redhead paint. Upon removing that green paint, I discovered, buried deep under layers of the old paint, carved onto the decoy's underside the letter "H." If I could select a single moment in my life that stirred and awakened the decoy collector's spirit in me, it was that moment. I knew somehow that it was right to get that green paint off that decoy, but little did I realize that the discovery of that never-before-noticed "H" would take me to a lifelong avocation.

It was to take me many decades to discover the origin of that "H." In an interview with the late Heisler McCall of Charlestown, Cecil County, Maryland, he revealed to me that it was the brand of Captain Joseph Heisler, McCall's grandfather, a gunner and guide from that same waterfront community. The decoy had been carved by Benjamin Dye, also of that town. That old decoy was carved circa 1850.

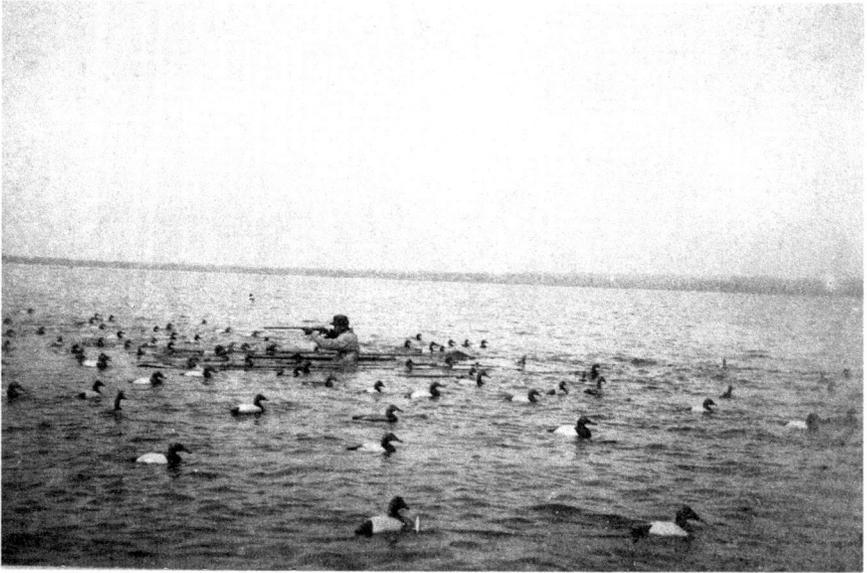

Charles R. Flint traveled from Carroll's Island to Havre de Grace for a morning's sinkbox shooting in March 1902. A rig of over seventy-five decoys surrounds him. *Collection of the Latrobe family.*

As the years passed by, I focused on Chesapeake Bay decoys, with an emphasis on decoys from the upper portion of the bay. After the Heisler branded decoy, the next branded decoy to join my early collection was a John "Daddy" Holly wearing the deep-set clear brand of Carroll's Island. Those decoys that wore brands declaring ownership by individuals, gunning scows and gunning clubs became my favorites. Of the many thousands of decoys that I have examined, I have had the opportunity to own fewer than sixty-five decoys that wear different brands. Holly carved all of the known Carroll's Island branded decoys.

Surviving records of the Carroll's Island Ducking Club make frequent mention of decoys. There was a sufficient quantity of decoys on Carroll's Island by 1852 that, according to the club minutes, a "duck house" was to be built and the cost assessed to the members. Again in 1858 and 1859, the minutes recorded the committee's decisions to arrange for the repair of decoys, blinds and boats. The club's treasurer's account of 1859 lists a purchase from Merrill, Thomas & Co. of decoys for the sum of $46.18. The firm of Merrill, Latrobe and Thomas of 204 Baltimore Street appears in Matchett's Baltimore City Directory of 1855–56 as a

manufacturer and importer of guns and gun locks. These records are of particular significance to the history of the decoys from the island. It has been the accepted practice in dating decoys of the Carroll's Island Club to assign a date to them of circa 1870 to 1890. I would suggest to any reader that, if a building was constructed to store decoys in 1852, there were obviously many decoys at the club at that time and, most likely, in the years prior to 1852 as well.

In Latrobe's recollections, he refers to shooting over decoys on the island. Before the blinds (there were eight of them), a stool of decoys numbering between seventy-five and one hundred would be anchored out each morning. The decoys were spread out over an area that began approximately ten yards from the blind, with the farthest out thirty-five yards. The stools were a mixture of canvasbacks, redheads, blackheads and baldpates.

In my research of the Harford County assessment records of 1896, I discovered the assessment of the Spesutia Island Rod and Gun Club. Among the members listed in that record were George B. Post and Henry A.V. Post. Years later, in my search for the elusive fowl, I came across a decoy wearing the brand "G.B. Post." The form of that decoy is unique and not typical to the Chesapeake Bay region. Each of the decoys that I have that wears the Post brand has a wide flat bottom with a wooden keel attached; applied to the wooden keel is a strip of flat lead ballast. The head is attached to the body with a wooden dowel. The dowel enters the top of the head and extends through the body. All of the known decoys with a Post brand are canvasbacks and are branded with "G.B. Post" or "C.A. Post." I have one other decoy of this unique form that is branded "Hidden," the meaning of which remains a mystery. Sometime later, I learned that the Posts were not only members of the Spesutia Island Club but also gunned at the Carroll's Island Gunning Club. The members of these clubs followed the migratory path of the ducks they hunted, from New York to Spesutia Island to Carroll's Island; the Post family obviously traveled this route. Along with their guns, they transported their decoys as well. In 1896, Charles H. Raymond wrote to the Harford County assessor, Herman W. Hanson, to appeal the assessment of the personal property at the San Domingo Ducking Club. He said, "This property is for my own present convenience held in Maryland although it is not permanent there. Some of it, shooting equipment, horses, wagons and clothing, etc., are also held and used in the State of New York and Canada, being moved to and fro from time to time as use may require."

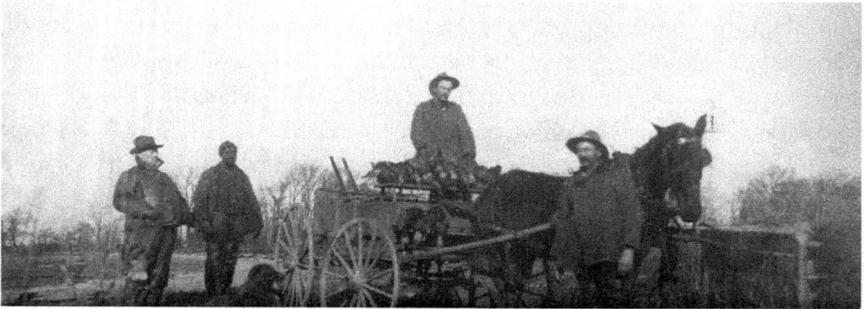

December 15, 1901, I.T. Norris and Charles R. Flint shot thirty-one black ducks over decoys. John, William and Josh are pictured with Norris and a Chesapeake Bay. *Collection of the Latrobe family.*

When Henry A. Fleckenstein Jr. published *Decoys of the Mid-Atlantic Region* in 1979, he included among the decoys pictured a blackduck carved by Edmund Hardcastle of Talbot County, Maryland. The image depicts one of the more unusual looking birds included in the book. This unusual decoy and the name of its maker remained in my memory because of the bird's unique appearance. Decoys by Hardcastle display an elongated, thin, flat body that rises to a broad, upswept tail. The most outstanding characteristics are the decoy's low neck and a protruding, oversized bill that drops below the face of the decoy.

Years later, examining the game books and gunning logs of the Carroll's Island Club, I came across the name of Hardcastle in association with decoys once again. On March 25, 1904, Edmund B. Hardcastle of Easton, Maryland, gunned at Carroll's. He was the guest that day of Hughlett Hardcastle, a club member. The Hardcastle name is repeated in the gunning logs on multiple occasions. On March 28, 1904, Hardcastle and his guest gunned with Theodore Marburg, another member. They reported, "Tide very low in morning and ducks decoyed badly. Very little shooting in afternoon." The game killed consisted of one redhead, fourteen blackheads and one fisherman.

Two years later, at the end of March 1906, Hardcastle, along with his guests, killed eighteen ducks. Under "Remarks," they entered, "Very hazy. Plenty of ducks moving early & late but pay no attention to decoys." Like the Post family, the Hardcastles probably brought their decoys to the island.

The game books and gunning logs of Carroll's Island are replete with references to decoys. The log for October 25, 1896, notes: "Sharp frosty

night, geese and swan are here. Some ducks seen on Friday past—very few today. Opening of the season, boats & decoys will all be distributed this week—everything ready for members." Decoys were used on the gunning points along the shoreline rather than on the famous Bar that extended out into the bay.

February 19, 1884: Birds would not decoy and flew very high all day.

March 4, 1884. Wind N.W. to W. intensely Cold. Ther.14°—good many ducks moving looking for chances to feed—thought so little of appearance—laid abed until sun up—had breakfast—went to the Bar—killed 2 canvas backs—seeing large rick of ducks under Weir Point, went over after midday meal put out decoys with the effect of starting all the ducks up the river—accordingly went back to the Bar & had a very enjoyable afternoon—killing 23 good ducks—day ends cold.

October 10, 1884: House was open with the old couple of servants—boats, blinds, and decoys all in good order.

October 26, 1890: On Oct 24th there was a very severe Easterly storm. Much damage was done to the blinds etc. lost Bar dugout boat, Schultz decoy boat broken in half—

December 28, 1896: Two bunches of canvasbacks (5 & 6 birds) passed over stool, rather high. Game killed: 11 Mallards, 2 Redheads, 2 Baldpates.

March 15, 1897. Gave the ducks a day's rest on Saltpetre side. All decoys up last eve! Game killed: 10 Redheads, 1 Blackhead, 1 Baldpate, 4 Swan Hew Cove.

March 21, 1897: There was a thick fog until about 12 noon—ducks would not come to bar, but decoy blinds were fairly good. Game killed: 40 Redheads, 2 Blackheads, 2 Geese.

December 16, 1903: Ice all over Saltpetre but some bunches, pairs, & singles decoyed, decoys being frozen in. Game killed: 9 Redheads, 1 Canvasback, 1 Green mallard, 1 Baldpate, 1 Crowbill.

March 14, 1904: Ducks came in in five bunches & decoyed well. Game killed: 16 Redheads, 1 Whiffler.

November 10, 1904: Plenty of ducks in Bay but did not care to make the acquaintance of the stool. Game killed: 2 Redheads, 1 Canvasback, 3 Trash ducks.

We know through historic assessment records and a few rare photographs that in addition to the duck decoys, Canada goose and swan

decoys were also in use at gunning clubs in the Chesapeake region. I have in my collection a photograph from the 1880s of the clubhouse at the Miller's Island Ducking Club. Adjacent to the porch, where two gunners rest with their guns and dog, sits a Canada goose decoy. It is evident from the photograph that the decoy was most likely carved by Albert Terry of Riverhead, New York. Terry carved in the mid-nineteenth century. Another photograph of the Miller's Island Club reproduced in Percy Blogg's *There Are No Dull Dark Days* shows a line of nine swan decoys sitting in front of the clubhouse. Goose and swan decoys of the early gunning clubs were far less numerous than duck decoys. The Taylor's Island Ducking and Fishing Club located on the Bush River in Harford County was assessed for four hundred duck decoys and twenty swan decoys in 1896. In that same year, the San Domingo Gunning Club located on the Gunpowder River in Harford County was assessed for five hundred decoy ducks and six swan decoys. Goose and swan decoys were used to enhance the large stool of decoys set out by the early gunners. Although no branded goose or swan decoys from Carroll's Island are known, we have the club records to verify their use on the Island: "March 17, 1903: Geese came up to the decoys. Game killed: 3 Geese, 5 Redheads, 1 Baldpate, 9 Blackheads."

The shooting of swan was also mentioned numerous times:

> *November 15–16, 1896. Very few ducks but more geese and swan than have been here for many years in fact more than ever in the recollection of any members of the Club. Game killed: 4 Geese, 3 Swan, 2 Blackducks, 1 Mallard.*
>
> *November 21, 1896. A great bunch of large game swan & geese, but no ducks on our waters. Game killed: 3 Swan (killed at one shot, 2 cygnets and 1 old bird), 1 Baldpate, 4 Whifflers, 1 Blackduck.*
>
> *November 22, 1896. Mr. Wilson killed 6 swan at Bar Point. This is the largest number of swan killed to a single gun of which there is any record at the Island—one swan killed at Lower Island—a great many swan & geese in our waters—but as yet no ducks—Mr. Wilson is champion now— Game killed: 7 Swan, 1 Dipper, 1 Blackhead, 1 Whiffler.*
>
> *November 15, 1911. Swan (old one and family of young) drifted past blind. Game killed: 4 Redheads, 4 Blackheads, 2 Ruddies, 1 Cygnet.*
>
> *November 11, 1912. Great quantities of geese and swan. The swan killed flew over the blind. Game killed: 5 Swan (all cygnets), 3 Redheads, 2 Blackheads, 1 Butterball, 1 Black duck.*

The Decoys of Carroll's Island

Although the Carroll's Island Ducking Club was not officially formed until 1851, sportsmen used the island from the 1820s. Many hundreds of decoys were used at Carroll's for well over one hundred years. (While the U.S. Department of the Army acquired the island in 1917, club members were extremely fortunate to have been able to lease back the island from the army during peacetime.) Yet in my forty years of collecting, I've seen but five decoys wearing the historic brand of Carroll's Island.

Following the years of the Carroll's Island Ducking Club, waterfowling continued on the Bar and gunning points on the island. A short history of duck hunting at the Proving Ground, dated October 15, 1955, is among the records maintained by the army. The Aberdeen Proving Ground Gun Club owned property with a total value of $9,000 to $10,000, including thirty-one rowboats with oars, thirty life preservers, one outboard motor and approximately two thousand decoys. Additionally, the Aberdeen Proving Ground Game Club owned thirty-two rowboats with oars and one outboard motor, but no decoys. Each member of the game club was required to furnish his own decoys. Undoubtedly, some of those decoys had seen active lives for many years before the formation of the gun and game clubs.

In the early days of my decoy hunting, I frequented the antique shops throughout the region; one of my favorites was Pete's Pickens in Upper Falls, Maryland. Louise "Pete" Clark quickly caught onto my passion for the wooden fowl. I can recall my best trip to her shop. Pete called me one Saturday morning over thirty years ago. She had just gotten in a group of decoys, and she wanted me to help her identify and price them. It was a group of about thirty old upper bay decoys. To the best of my recollection, the majority of them wore several coats of old paint. There were Mitchells, Gibsons, McGaws, Hollys and other well-used birds. As I turned each of them over, I noticed that most of them were wearing the brand of the United States Army Ordnance Division (the brand was the symbol of ordnance). I separated those from the remainder of the group. The others appeared older to me and just felt different. As I turned them over one at a time, I discovered that these decoys also wore brands. They had seen service before the arrival of the army in the rigs of other ducking clubs. One had a flat iron ballast weight with the raised initials E.L.B. (the identifying ballast weight of Edward L. Bartlett of Bartlett and Hayward); two others were branded "Philadelphia Gunning Club." The Bartlett decoy, the Philadelphia Gunning Club decoys and one of the ordnance decoys came home with me that day. The others stayed in the shop for many months. I thought there would be many opportunities

to buy other ordnance branded decoys if those were sold. How wrong I was. They disappeared over the years, and I have not had the opportunity to purchase another since that day. Little did I realize in those days that those decoys, like those of Carroll's Island, would someday be rare and sought after by collectors. They are, like the older wooden fowl, a piece of waterfowling history, completing the story of a sportsmen's paradise, Carroll's Island.

THE CARROLL'S ISLAND GAME BOOKS AND DAILY JOURNALS

How many anecdotes and curious facts might be collected and preserved—if the worthy occupant [Colonel William Slater] of Carroll's Island would keep a brief journal of things done by the gentlemen of long boots and long barrels!" quipped the *American Turf Register and Sporting Magazine* in December of 1834. This lament was repeated throughout the years. The Carroll's Island Game Book of January 1, 1888, remarked,

> *I notice no record since Dec. 9, '87 made by Capt. Barnes, and I feel some of our members have not recorded their presence at Carroll's, some of our members have been here and I know ducks have been killed;—if they do not enter the same, our record must run behind previous years', still it has been a poor season at best.—tho if our members would only come and record their doings we would make a better show.*

Volumes of records do exist, however: two large black leather-bound volumes with covers gold-stamped "Carroll's Island Game Book"; small, paperboard-bound "Daily Journals" tied at the top with strings; and the "Carroll's Island Visitors' Book" bound with marbleized boards and a leather spine. The game books and daily journals cover the last two decades of the nineteenth century and the first decade of the twentieth century. The visitors' book encompasses the first three decades of the twentieth century. These historic volumes reside in the H. Furlong Baldwin Library of the Maryland Historical Society.

Members are requested to fill up these blanks each day and place the same on the Secretary's file. If no game be killed please note memoranda of weather. All entries in the Game Book must be made from these slips.

Carroll's Island _Apl 1st_ 189 _9_

Name _I O Norris & Lillenberg_

Locality _Sour Island hollow_ No. of guns _____
+ Schuster + Stubby

GAME KILLED.

No.	SPECIES.
4	Red Head
7	Bald Pates
1	Blk Duck
1	Teal Blue Wing
13	TOTAL

Wind _N to NW_ Weather _____

Bar. _____ Ther. _____ Hour noted _____

Remarks _____

The Carroll's Island Game Books and Daily Journals

I have spent hours reading through these daily journals and game books, as well as the records of other gunning clubs and properties. Sadly, most of these wonderful properties are gone to other uses. Only the land remains; there are no buildings, no chance of anyone living on those lands or enjoying sport there. It is only the personal recollections preserved in journals and game books or in such rare documents as the work of Ferdinand Latrobe, John Cadwalader's reminiscences of Maxwell's Point and the photographic images carefully preserved through the years that can take us back to that time and place.

I grew up in Fallston on a property that my paternal grandparents purchased in the 1880s. My grandparents were young then and they raised five children in that old house that had been built on land

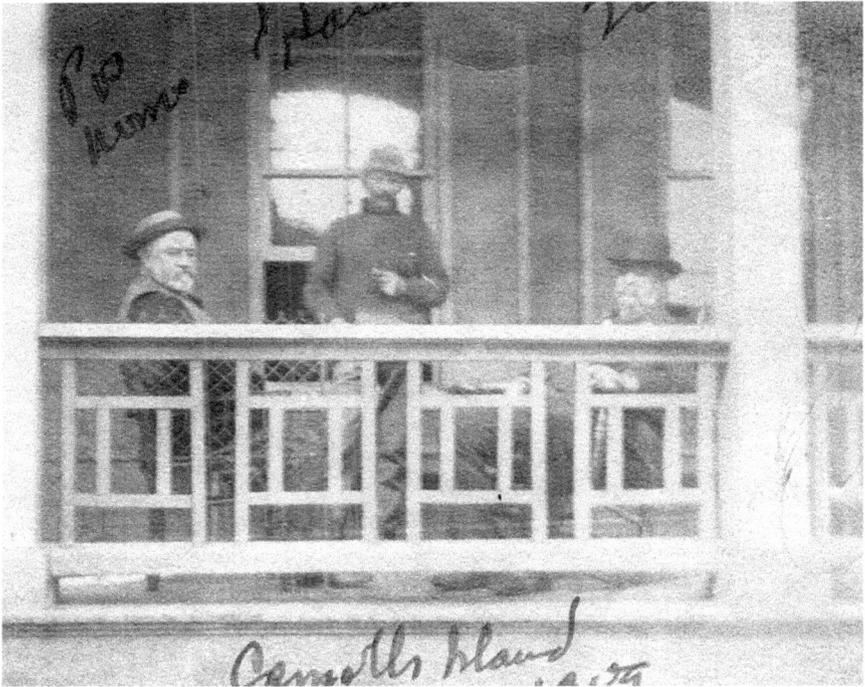

Above: Pos Norris, Dr. Hardcastle and F.C. Latrobe resting on the porch at Carroll's Island in 1909. *Collection of the Latrobe family.*

Opposite: According to the daily journal of April 1, 1899, J.O. Norris and T. Marburg gunned at Lower Island hollow, Schultz and Stubby. The wind was west to northwest. They shot four redheads, seven baldpates, one black duck and one blue wing teal. *Maryland Historical Society.*

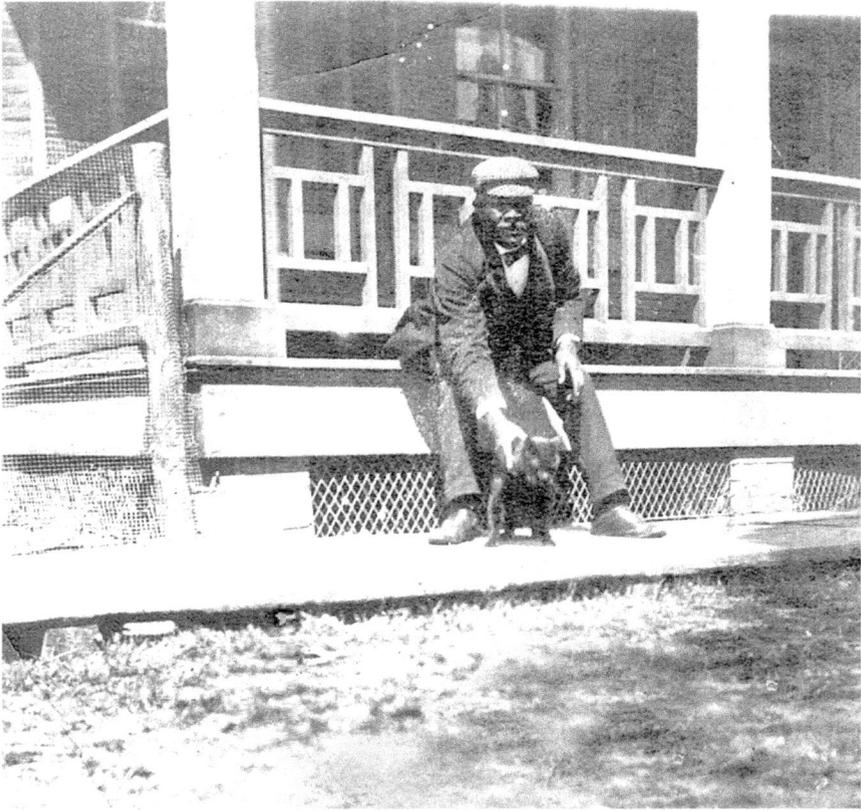

Above: A peaceful moment by the porch at Carroll's. Albert holds his favorite cat. *Collection of the Latrobe family.*

Opposite: Inauguration Day for the twenty-seventh president of the United States, William Howard Taft, March 4, 1909. The island is under a blanket of snow. *Collection of the Latrobe family.*

known as Stoney Batter. It wasn't an estate, but a nice little country farmhouse. My parents moved into that house when they were married in 1936, and my sister and I grew up there in much the same way as my father and my aunts and uncles had. We had our own cows, chickens, a couple of horses and always a Chesapeake Bay retriever. My mother is now ninety-six and is still living in the house where my father took her after their honeymoon over seventy years ago. I am blessed that my family's home and immediate surroundings appear much the same today as in my grandparents' time. While I admit there

is little to compare my family's humble property to wonderful gunning properties such as Carroll's Island, the similarity in historic images and journal entries strikes me—both my mother and her mother each kept a daily journal throughout their lives. The days before television, computers and a host of other modern-day gadgets allowed families and friends of all stations to work, play and amuse themselves in much the same way.

While the ducks were being lured into shotgun range at Carroll's Island or another gunning shore, one of my grandfathers was shooting a rabbit, a squirrel or a quail in the woods or fields around Fallston, while the other was shooting targets with his English-made double. While the Chesapeake Bays of Carroll's were eagerly awaiting their next retrieve, our family Chesapeake was an eager companion in the outdoors. The sportsmen and my family members all wrote of the daily weather and unusual weather phenomena. "It blowed a living gale" my grandmother wrote, while a club member recorded "the highest tide known on the [Carroll's] Island since '93, water all over marshes and road…Looks like ocean over the road, waves actually breaking—like Noah's flood." Housekeeping matters were also noted: "Drove well for water near garden fence [on Carroll's Island]. So far a plentiful supply."

The daily journal and game book excerpts that are included in Appendix II to this volume bring back to life the daily lives of the sportsmen on the island—the camaraderie they shared, the wildfowl they shot and the natural world they escaped to from their business lives in Baltimore, New York and Philadelphia. As Percy Thayer Blogg wrote in 1944, "Fate set me down at an office desk. 'Tis here you must toll' said she. But fortune brought me a dog and gun…and thus through fortune I laugh at fate at office desks and at bores, for while I tread my four-walled mill the other man in me lingers still in my part of God's outdoors."

Years ago when I visited Carroll's Island with Dr. Prescott Ward, we walked around the two structures remaining there, one a concrete block, single-story building used for testing and monitoring the site and the other an observation tower. There were traces of where the once-great clubhouse had stood, yet nothing but the land was left from the great early days there. We walked through lush green grass about one foot tall. It waved in the breeze as we walked to the river's edge. We walked around the shoreline looking into the eroded bank for oyster shells and artifacts. All was quiet that day, save for the

water lapping against the shore. As I stood there contemplating what this spot once was, I thought of all who have been on these shores. I hear the famous Bar is now gone. Only a small piece of it remains visible, standing by itself far offshore in the river. Nothing, it seems, is meant to last. Were it not for the photographs and their captions, the journals, game books and the oral and written histories, the memory of this place would have faded as the footprints of the men of long boots and long barrels washed away.

EPILOGUE

On April 6, 1917, the United States entered World War I, and on October 16 of that year President Woodrow Wilson issued a proclamation that, pursuant to the authority vested in him by an act of Congress, he did "hereby order and declare that the following described tract of land was necessary for the purposes specified" for the United States Army. Within the meets and bounds of that parcel of land was Carroll's Island. The war to end all wars changed this part of Maryland forever. At of the end of November 1917, S. Davies Warfield of the Carroll's Island Ducking Club received a letter from Newton D. Baker, secretary of war, ordering the evacuation by the sportsmen of Carroll's Island. To mark the end of the long association of sportsmen with the island, Warfield invited twelve guests to a celebration. The guests who joined him were J.H. Wheelright, Clarence W. Watson, Albert H. Wiggin, Benjamin Strong Jr., Charles H. Sabin, Daniel E. Pomeroy, Seward Prosser, Samuel McRoberts, Gates W. McGarrah, Alvin W. Krech, J. Horace Harding and John F. Harris. As a commemoration of the occasion, Warfield gave each guest a small book, *The Passing of Carroll's Island*, which he had written and published in an edition of twenty copies. Twenty-four years earlier, on March 6, 1893, the following note had been penciled in at the end of the Daily Journal entry: "Twenty years from now what will be the outlook on Carroll's and how many of the present members will be enjoying life?" Ferdinand W. Roebling and J. Olney Norris were the two shooters that day.

As the sportsmen's guns were silenced on Carroll's Island, the first shots of the huge guns of the United States Army were fired on January

The lawn at Carroll's with F.C. Latrobe, T.S. Latrobe and Thomas Swann in 1886. *Collection of the Latrobe family.*

2, 1918, at noon on the Aberdeen Proving Ground. It was such an occasion that a special train "for the convenience of guests" provided transportation to the site, where Mrs. E.V. Stockham, daughter of the late Pennsylvania Governor Hartranft, fired the first gun.

The sportsmen's guns remained silent while the army occupied the island during the war years. The armistice ending that war was signed on November 11, 1919. Whatever testing occurred on the island was ended and, shortly thereafter, the island was leased back to S. Davies Warfield. The lease continued in his name until his death, and thereafter was renewed in the names of other club members. During the 1930s, when duck shooting was more restricted by state and federal legislation, many club members dropped out. The obligations under the lease were assumed during those years by Edwin G. Baetjer and his brother, Howard Baetjer. The last lease in place prior to the United States' entry into World War II was dated February 5, 1941. This was the third lease in the Baetjer name, each

Project	Aberdeen Proving Ground, Maryland
Name of Owner	Carroll's Island Co. of Baltimore County, Inc.
Property Number	211
Area of Parcel	1212 Acres
Price Paid	$120,000.00
Appraised Value	$120,000.00 by Land Commission February 14th, 1918 Ref. Page 82, Book A Page 88, Book B
Method & Date of Acquisition	Purchased December 23rd, 1918
Possession Taken Under	Proclamations of the President of the United States dated October 16th and December 14th, 1917
Record of Acquisition	Voucher No. 57166 – F/ J. Keelty, Maj., Ordnance Deptl, dated March 23rd, 1918
Remarks	

This document records the official taking of the island on December 23, 1918, for $120,000. *Collection of Frederick O. Mitchell.*

for a term of three years. The United States, once again, terminated duck shooting at Carroll's Island on July 13, 1943. Testing resumed on the island and continued through the end of the war. On April 22, 1946, Howard Baetjer wrote to Brigadier General E.F. Bollene of the Department of Chemical Warfare at Edgewood Arsenal requesting that the lease to the Carroll's Island Ducking Club be reinstated. In his letter, he requested that A.H.S. Post, the president of the Mercantile

Trust Company of Baltimore, be substituted for his brother, the late Edwin G. Baetjer. Prior to World War II, these men had leased both the island and Grace's Quarter for their sport. Now, they requested the new lease be only for Carroll's Island, and the rent reduced accordingly to two-thirds of the previous rent. On October 24, 1946, Brigadier General A.B. Quinton Jr. wrote to the division engineer of the Middle Atlantic Division,

> *This office has been advised by higher authority that the Secretary of War has directed that Carroll's Island be leased to the above named individuals* [Howard Baetjer and A.H.S Post]. *Accordingly, it is requested that your office draw up and negotiate a lease with the two aforementioned individuals to be effective as soon as the terms of the lease can be drawn up, and to continue in effect until 15 February 1947.*

A shed on the island with a warning to all of what brought an end to this waterfowling paradise. *Department of the Army.*

Epilogue

The road to Carroll's appears peaceful on what was to become a Superfund site.
Department of the Army.

The army leased out lands to others in addition to the gunning clubs. Harry G. Hopkins, Grason's son, told me in an interview on March 1, 2007, that when he was a teenager in the late 1940s, his father had leased farm land on the Proving Ground. The lease was for Cranberry, the farm where the Hopkins family had once lived. Harry related that as he was plowing one day with one of those old John Deeres with the two-cylinder engines and the hand clutch, he had nearly fallen asleep as he plowed across one of those long, flat fields. He was startled as the tractor came to an abrupt halt in the middle of the field, and he looked down to see the rear wheels spinning. Knowing that there were virtually no rocks in those oft-plowed fields, he got down from the tractor to see a huge, unexploded ordnance shell up against the tractor's wheel. The army had warned his father that there might be some unexploded rounds in the fields. Across the Bush River on the Gunpowder River Neck, the Cadwalader family was not so fortunate. Once the army had taken possession of their land, it was over for the Cadwaladers—there were no lease agreements, no farming, no gunning. As the family had indicated in their journal it was over, finis, the end.

When the island was taken by the army, the Carroll's Island Company of Baltimore County Incorporated was paid $120,000 for 1,212 acres. The recorded date of the transaction was December 23, 1918. The value was based on an appraisal by the Land Commission in February of that year. It was the 21_th property taken by the army for the military reservation.

95

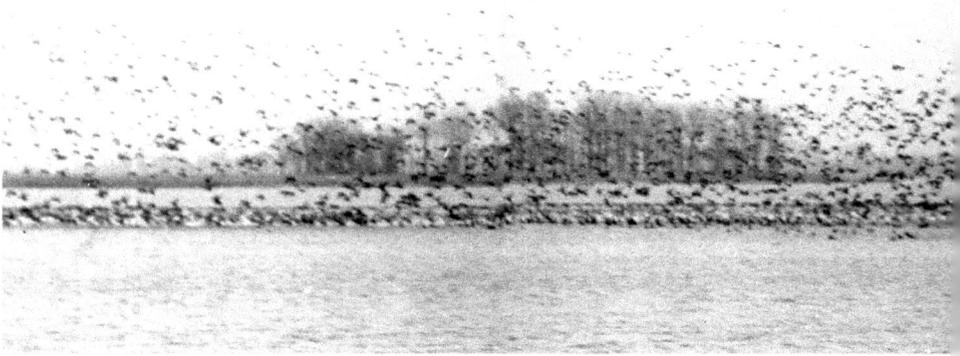

On December 3, 1936, W. Bryant Tyrrell took these photographs of fifteen thousand ducks, canvasbacks, redheads and scaup at Bay Cove on Carroll's Island.

Twenty-two years prior to the taking, William B. Hurst of John E. Hurst and Company challenged the assessor's valuation of his property on the Gunpowder Neck in Harford County. Hurst wrote this as to the land's value:

> *The 177 acres of marsh land which you* [the assessor] *value at $10.00* [per acre] *and I at $5.00, I can not but think $5.00 is a very reasonable estimation, as it is worthless for any purpose except duck shooting, and as everyone knows, the ducking has become less and less until now it almost appears to be a thing of the past. Why then should land such as this be assessed at over $5.00?*

Epilogue

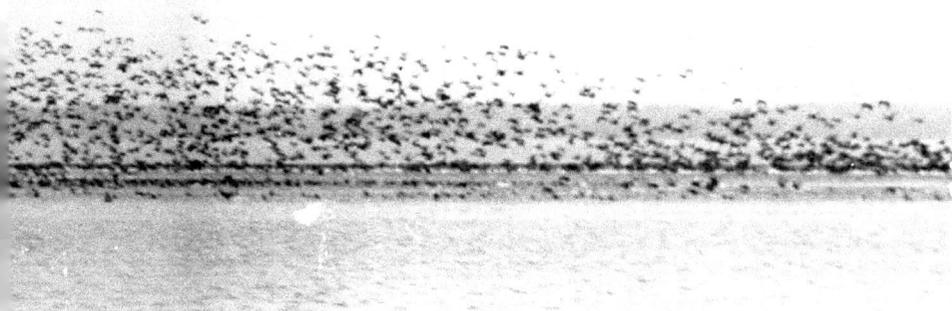

Although two decades had passed from the time of his comments to the time of the taking, the compensation paid by the army seems reasonable in light of Hurst's analysis. Yet all of the families that I have spoken to whose land was taken share the sense that their land was taken without just compensation. Perhaps the reality is that this beautiful paradise was priceless to those who lived, farmed and hunted there.

I have often contemplated what this land would have been today if the army had not taken it. But is the reality of what it is today worse than what it could have been? I fear that offices, industrial plants, marinas and today's high-dollar condos and townhouses would cover the waterfront. Instead, now the Environmental Protection Agency and the United States Army oversee the cleanup of this designated Superfund site while our nation's bird, the majestic bald eagle, has increased its numbers there. The island sits vacant today, save for the suggestion of an indentation in the soil where the once magnificent clubhouse stood, a single block shed, an observation tower and the ghosts of our defense industry lying just below the surface. Perhaps this is a fitting tribute to this one-time land of paradise; it lies vacated while the great flocks of fowl fly overhead undisturbed by man, enjoying their peace as in many years past.

APPENDIX I

CARROLL'S ISLAND DOGS: THE STUDBOOK OF FERDINAND CLAIBORNE LATROBE

1883.

February.
LADY had 10 puppies, by CHAMP. None on Island.

1884.

April.
LADY had 4 puppies by ROCK. No good.
DAN. The great sire of Carroll's Island stock. The history of this remarkable dog is worth telling. John Johns, one of the attendants, was going along the Philadelphia turnpike, about 1881, when he met the wagon of Mr. Williams, on the road. Tied behind the wagon was a thin distressed looking dog of the Chesapeake Bay kind, dirty and muddy. To an enquiry of what he intended "doing with that dog?" the man replied, that he was going to take him up the turnpike somewhere, and lose him. The dog had come to him astray, he didn't want to kill him, so he was going to lose him. John requested him to give him, John, the dog, which he willing did. John brought the dog to the Island and gave him to Mr. J.S. Frick as a substitute for a dog of Mr. Frick's which he, John, had lost. He was poor and miserable

looking, half starved, and his teeth all worn down from gnawing bones. Mr. Frick named him DANIEL; (certainly he looked as if he had come from a lion's den). He became really a landmark on the Island. Great intelligence, great endurance, and, when thoroughly trained, no wind or ice stopped his pursuit of a duck; and he knew all the dodges for catching a crippled fowl. In the latter part of his life, he lost an ear in a battle—but was as good as ever. DAN is dead [1888], "Requiescat in pace."

1885.

[missing]

1886.

List of dogs on Island, Oct. 20, 1886.
LADY. Came from Dog Pound, given to F.C.L. by Keeper of Pound.
JEANNIE. Out of LADY, by CHAMP (dead)—was a large yellow Chesapeake Bay.
ROVER. Grace's Quarter and Bengies stock. Dead.
BURKE. Dr. Keener's stock out of BRAVE.
POLLY. Joe William's stock, Back river.
DRAKE. Joe William's stock, Back river.
TOM. Out of POLLY by DRAKE.
ZIP. Out of JEANNIE by DAN, born 1885.
TURK. Out of JEANNIE by DAN, born 1885.
RICK. [?] Spaniel, Bloody[?] stock.

1887.

[missing]

1888.

DAN. Died in summer of 1888, was a first class dog, long coarse hair, dark liver color—small size, died of old age and hard service.

<u>Dogs on the Island. December.</u>
BURKE. Purchased by Raleigh Thomas. Out of Dr. Keener's ROSE, by a Marshy Point dog. Died Fall of 1891.
JEANNIE NO. 2. 3 years old. Pupped in 1884. Died in 1895. By DAN, out of JEANNIE No. 1.
JEANNIE NO. 1. 1883 by CHAMP—a large yellow dog, stout, well built, and a fine fighter (was killed on that account), brought to the Island by F.C. Latrobe. Her dam was LADY (pupped Fall of 1880), a fine slut, and did good work for many years; she was given to F.C.L. by Mr. Hamlin, keeper of the dog pound, an old ducker. JEANNIE No. 1 was of a yellow color, coarse wavy hair.
TURK. By DAN, out of JEANNIE No. 1. Roebling had him broken. Dark liver color, very much like old DAN Died, summer of 1890, he was a very fine dog.
TOM. 3 years old. By DRAKE, out of POLLY. Both DRAKE and POLLY were bred by Joseph Wilkins. They were both good dogs and did good work for Mr. Wilkins, who gave them to F.C.L., who brought them to the Island. TOM was bred by Mr. Wilkins, and given as a pup to F.C.L., who gave him to Mr. Norris. Died, summer of 1889.
JACK. 3 years old, July, 1888. Purchased from Josh Wilkinson by Mr. Thomas. Bred at Marshy Point. A fine decoy dog, plenty of snap, will jump off the highest blind, and never tires. A smooth coated dog, brownish yellow. JACK wore out by hard work.
DUCK. Died while pupping. DUKE. Died 1891. Benjamin F. Harrison. Died 1894. These dogs were whelped in July 1888. They are by GROVER CLEVELAND, out of BELLE.
GROVER CLEVELAND was a celebrated dog at Walnut Grove. His dam was a fine bitch owned by Hamlin, who sent her to the Walnut Grove dog to get a litter of pups. She only had two, and died soon after. One of them was GROVER C., and was given to F.C.L. by Hamlin. BELLE was bred at the Japanese Fishing Shore, and was given to F.C.L. by Henry Snyder. Neither GROVER CLEVELAND or BELLE were ever on the Island. DUCK was given to J. Swan Frick; and took 2nd prize at the Bench show of 1890 in Baltimore; DUKE to Com. Floyd Jones, and BEN to Mr. Roebling by F.C.L. (Diary of F.C.L.) July 2. Monday. Slut BELLE had 8 puppies at Ferry Bar. These pups were sired by GROVER CLEVELAND, and are full Chesapeake Bays. Distributed as follows:
DUCK. Sent to Island. Given to J.S. Frick.
DRAKE. Sent to Island. Given to Mr. Floyd Jones.
BEN. Sent to Island. Given to T. Swann Latrobe.

Appendix I

Tip. Sent to Island. Given to Mr. Roebling. Died.
Pup given to Joseph Wilkins.
Pup given to Henry Snyder.

July 4.
Pup was given to me by Pike Lucas. Bred by Jerry Mallory, on Back river. This pup, a slut was sent to Mr. Fred Roebling to have broken for the Island.

Oct. 1.
Slut pup given to me by John S. Gittings, a Chesapeake Bay. Pupped Oct. 1. 1888, out of his slut Turk from Carroll's Island.

Lou. Brought to the Island by Meredith Jenkins. By John Ridgely of Hampton.

Buck. Dam, J.R. of H's Belle. Belle was by John Stewart's Turk, out of Henry Johnston's.

Juno. Both Turk and Juno were on the Island some years ago and were celebrated dogs. Juno was a very fine slut, one of the best. Died at Wheatland from Dog-shore sickness. Buck was bred at Hampton. Sire Nero, a great fighter, he at one time attached a tramp, and bit him severely, and was killed. Lou was given away from the Island in summer of 1890.

Sprigg. Brought to the Island by Mr. Hermann Oelrichs, was of Maxwell's Point stock, bred by Lynch. Sprigg is a fine large dog, good all around, works well on the Bar, and over decoys, is red, well coated, with white frill. The fastest swimmer ever known on the Island, & the most intrepid and longest distance jumper from a blind—a grand dog in every way. Oct. '92, Sprigg is old and infirm, but he has done good service and will be well cared for. Died in the winter of 93–94.

Rose. Name changed to Zip. Pupped June 1888. Bred at Mr. Jerry Mallory's place on Back river, below Twin Oak. Sire and dam owned by Mr. Mallory. Rose or Zip was given to Josh Wilkinson. The mother of Zip was Mary who took first prize at Dog Show in Baltimore, 1890.

Zip was given [back] to Josh Wilkinson, and by him given away.

November 24, 1888.
Took down with me Ben Harrison, Chesapeake Bay pup.

1889.

FRED. Was pupped in the fall of 1888, he was bred by Walter Townsend, and given to F.C.L. who brought him to the Island, March 1889. (Given to Josh Wilkinson, March, 1890—turned out poorly.)

(Diary of F.C.L.) LOTTIE. Was by TURK from John S. Gittings' slut, pupped Oct. 1888. [?] to Crimea. Died of distemper.—A litter of pups from GROVER CLEVELAND out of BELLE at Ferry Bar, 3 dogs & 3 sluts, March 1889.—Gave a dog pup to Love [Secretary Love under Mayor F.C.L.] for our Governor Lloyd.—A litter of pups out of JEANNIE by JACK at Carroll's Island. She had 15 pups, we retained 7.

RYE. Pupped in the summer of 1889. Dam JEANNIE NO. 2. Sire JACK NO. 1. Was sent to Mr. Roebling, who had him broken, and then brought to the Island in the fall of 1890. Oct. 1892, RYE has turned out pretty well, good decoy dog, active, not afraid of cold weather, longer haired than either sire or dam. Died spring of 1893.

PETE. Pupped in summer of 1889. (Brother of RYE). Turned out poorly, given away.

ROCK. Pupped in summer of 1889. (Brother of RYE.) Given away by Mr. Roebling.

FRITZ. A celebrated sire of Carroll's Island stock, perpetuating the fine qualities of DAN. Pupped September 1888. Sire TURK NO. 1. Dam, John S. Gittings' GRACE. GRACE was by a dog belonging to Fred May, on of the best Eastern shore type. Dam of GRACE was of Lego Point strain, bred by Dr. Keener. FRITZ was brought to the Island by J. Swan Frick in the fall of 1889. Dr. Keener's dogs were of the old "Rose" strain. TURK was by DAN, out of JEANNIE NO. 1. He was one of the best dogs ever on the Island. He had all the characteristics of his distinguished sire DAN, although not looking like him, being long legged and shorter haired. He was sent to Mr. Roebling when a pup, and thoroughly trained by him. Oct. 1892 FRITZ had turned out remarkably well, strong, active, quick, good retriever on land as well as water. Feb. 1896 FRITZ rheumatic and old, but still ardent and willing he is the sire of a lot of pups by FLIRT and MOLLIE in fall of '96. Probably his last effort. Was given to Jim Gibson at Chase's, in fall of '97. With all his qualities as a sportsmen's dog, FRITZ is kind and gentle and affectionate to the greatest degree. Dignified and quiet in the house, asking recognition as a gentledog of good family breeding, his behavior is without reproach. Out of doors, on the Bar or in the blind he is loyal, true and brave. FRITZ

has a wonderful nose, will wind a wounded or dead duck in the marsh a long distance. Found a goose in the marsh, shot dead the evening before by Wilson, and given up for lost until FRITZ found it the next morning.

1890.

<u>Dogs.</u>

BIRD. Pupped in spring of 1890. Grand dam BELLE—from Japanese Shore, never at Island. Grand sire GROVER CLEVELAND. The dam of BIRD was given by F.C.L. to a friend of James A. Busey, who gave BIRD to F.C.L. in the summer of 1890. Drowned in summer of 1891.

BELLE. Pupped in spring of 1890. Dam JEANNIE No. 2. Sire SPRIGG. Turned out poorly—given away.

TURK No. 2. Pupped in spring of 1890. Dam JEANNIE No. 2. Sire SPRIGG. Oct. 1890, sent to Mr. Roebling for training. Died in summer of 1891.

MAJOR. Pupped in spring of 1890. Dam JEANNIE No. 2. Sire SPRIGG. Oct. 1890, sent to Mr. Roebling for training. Sent back to the Island in summer of 1891. Turned out worthless and was sent away.

(Diary of F.C.L.) May 1, 1890. JEANNIE had pups by SPRIGG, 4 dogs, 1 gyp. BEN Harrison. Was always ugly, with a big bull head, and short curly hair, nevertheless, he was a good one, never afraid of cold water, good land and water retriever, and will continue to improve, when young had sore eyes. BEN got into a fight in the fall of 1894, had one ear bitten off, and died soon after of lockjaw.

DAISY. Bramble. (Belongs to John Bramble). This slut is from Grace's Quarter stock, and was brought to the Island for the club for breeding purposes, in the summer of 1891. This slut was purchased by the Club in 1892 for $10. Sedge color. March 11, 1892, this bramble slut had four pups, 2 dogs, 2 sluts, by SPRIGG. The two dogs died when about a week old. The gyps are named MOLLIE & GYPSY. GYPSY died in summer of 1892. DAISY was given away.

JACK No. 2. This dog belongs to Genl. John Gill. Bred at Grace's Quarter, brought to the Island in the fall of 1890. Left the Island in fall of 1894. [In 1887, General Gill, then a member of Grace's Quarter, presented the club with a dog named JACK.]

JIM was by DAN out of JEANNIE No. 1. A full brother to TURK, also to JEANNIE No. 2. He was given to Dr. Charles Tilghman, on Wye river, Eastern Shore of Maryland, who named him after Jim Frick.

1891.

DARBY & JOAN. Pupped in 1891. Sire JIM; dam T.B. Ferguson's BEAUTY. These pups were bred by Charles H. Tilghman, on Eastern shore. JOAN [1897] was liver colored without a white mark on her. Her coat was like that of an Otter. DARBY has a little "tan" about his head and legs, and two "tan" marks over his eyes.

BEAUTY was a bitch owned by Mr. Hopper of Havre de Grace. T.B. Ferguson in a letter to F.C.L., dated Dec. 30, 1891, says "I don't know the breeding of Mr. Hopper's bitch, nor did have the pedigree of MAJOR. MAJOR was given to me when a pup, and was bred on Spesutia Island, he was the best retriever and 'all-around' dog I ever saw, and had more intelligence than any dog I ever knew." Both of these dogs turned out well. JOAN 1st class in every way. DARBY a good retriever, but slow & sulky, with a tendency to eat ducks if not carefully watched. DARBY has turned out a first class decoy dog. 1896. DARBY died October 1897.

1892.

MOLLIE & GYPSY. Pupped, March 1892. Dam DAISY. Sire SPRIGG. Sedge color. GYPSY died in summer of 1892. 1896—MOLLIE has turned out to be a most excellent retriever. MOLLIE died in March, 1901.

JEANNIE NO. 2. Had a litter of pups born April 1, under the Magazine. All of these pups died in the summer of 1892.

List of Dogs on Island. Fall of 1892. October 1892.

JEANNIE NO. 2	Sire DAN	Dam JEANNIE NO. 1
SPRIGG	Bred by Lynch	
BEN	Sire GROVER CLEVELAND	Dam BELLE
RYE	Sire JACK NO. 1	Dam JEANNIE NO. 2
JACK NO. 2	Bred at Grace's Quarter	

Daisy	Bred at Grace's Quarter	
Mollie	Sire Sprigg	Dam Daisy
Darby	Sire Jim	out of Ferguson's slut Beauty
Joan	Sire Jim	out of Ferguson's slut Beauty
Fritz	Sire Turk	Dam Grace, John S. Gittings' slut
Gypsy	Sire Fritz	Dam Daisy

Judy & Gypsy No. 2. Pupped, December 1892. Sire Fritz, dam Daisy. Judy was given to the Bengies Club, in 1893. Gypsy No. 2 was given away.

1893.

Pat & Drake. Pupped March 17, 1893, St. Patrick's day. Sire Fritz, dam Joan. Died spring 1893.

Joe. This dog was sent to the Island in March 1893, by Mr. James C. Carter, from Currituck, returned to Currituck for use of Mr. Jas. C. Carter, January 1895.

Mac & Juno. Pupped in August 1893. Dam Daisy, sire Fritz. Mac given away. Juno taken by Mr. Floyd Jones in 1894. She turned out well and is much prized by Mr. Jones. Juno had two pups, 2 dogs, Gunner & Bowser, in 1894, by Fritz. These pups are in the possession of Mr. Floyd Jones.

5 Pups, 2 dogs and 3 gyps, pupped October 1893. Dam Joan, sire Fritz. Of these Jack No. 3 and slut Gill were taken by Mr. Roebling, January 1894 to train. 1893, Jack No. 3 was in a lunk-head [?] and disappeared. Was no good, and given away in spring of 1896. Drake No. 2 changed to Hector, taken by Mr. Floyd Jones in 1894. Jeannie No. 3 given away in 1894.

Gill. By Fritz, out of Joan. Pupped, October 1893. Was taken, January 1894 by Roebling to train, was returned to the Island in the fall of 1894,

106

has turned out well, a good retriever, strong and active. GILL died in the fall of 1902. She was rather light colored, wavy coarse hair. She did long and faithful service, dying full of years and honors.

LUCY. Snyder. Slut pup, sent to F.C.L. by Henry Snyder, born December 1893, at Japanese Shore, said to be very fine, brought down to Island by J.O. Norris, February 1894 Was taken to Baltimore by J. Swan Frick, and died of distemper in summer of 1894.

HECTOR. Was given by Mr. Floyd Jones to Mr. E.H. Barton, at Cedar Kennel, near Suffolk Club, in 1894.

List of Dogs on Island, October 1893.

JEANNIE NO. 2	Sire DAN	Dam JEANNIE No. 1	
SPRIGG	Bred by Lynch		Died winter of 1893–94
BEN	Sire GROVER C.	Dam BELLE	Died in 1894
JACK NO. 2	Bred at Grace's Quarter		
DAISY	Bred at Grace's Quarter		
MOLLIE	Sire SPRIGG	Dam DAISY	
DARBY	Sire JIM (Dr. Tilghman's JIM)	Dam Ferguson's slut BEAUTY	
JOAN	Sire JIM (Dr. Tilghman's JIM)	Dam Ferguson's slut BEAUTY	
FRITZ	Sire TURK	John S. Gittings' slut	
GYPSY (gone)	Sire FRITZ	Dam DAISY	

JOE	Came from Currituck		
MAC (gone—Mr. Jones)	Sire FRITZ	Dam DAISY	
MAY (Mr. Jones)	Sire FRITZ	Dam DAISY	
DRAKE No. 2 (Mr. Jones)	Sire FRITZ	Dam JOAN	
JEANNIE No. 3 (white foot)	Sire FRITZ	Dam JOAN	
Roebling's dog pup	Sire FRITZ	Dam JOAN	
Roebling's slut pup	Sire FRITZ	Dam JOAN	
FLIRT (fall of 1894)	Sire JIM	Dam Ferguson's slut BEAUTY	

1894.

List of Dogs. Fall of 1894.

JEANNIE No. 2	Sire DAN	Dam JEANNIE No. 1
JACK No. 2	Bred at Grace's Quarter	
MOLLIE	Sire SPRIGG	Dam DAISY
DARBY	Sire JIM	Dam Ferguson's slut BEAUTY
JOAN	Sire JIM	Dam Ferguson's slut BEAUTY

FRITZ	Sire TURK	Dam John S. Gittings' slut
JOE	Came from Currituck	
JACK NO. 3	Sire FRITZ	Dam JOAN
GILL	Sire FRITZ	Dam JOAN
FLIRT	Sire JIM	Dam Ferguson's slut BEAUTY

1895.

List of Dogs. Spring of 1895.

JEANNIE NO. 2	Sire DAN	Dam JEANNIE NO. 1	Died summer of 1895
MOLLIE	Sire SPRIGG	Dam DAISY	
DARBY	Sire JIM	Dam Ferguson's slut BEAUTY	
JOAN	Sire JIM	Dam Ferguson's slut BEAUTY	
FRITZ	Sire TURK	Dam John S. Gittings' slut	
JACK NO. 3	Sire FRITZ	Dam JOAN	No good, given away in spring of 1896
GILL	Sire FRITZ	Dam JOAN	
FLIRT	Sire JIM	Dam Ferguson's slut BEAUTY	

JEANNIE NO. 4. From Miller's Island. This slut was given to F.C.L. by James Dorsey, in the fall of 1894, then 6 months old. She came from Miller's Island; part of Mallory's stock. She was never thoroughly broken. Died, Oct. 1897. JEANNIE NO. 2. Died in summer of 1895. She had done good and long service, and died from old age. R.I.P.

Fall of 1895.
MOLLIE. Bred to FRITZ.
FLIRT. Bred to FRITZ.
JEANNIE NO. 4. to DARBY.
GILL. to DARBY.

1896.

A. Jan. 17.
MOLLIE had 7 pups. 5 died—2, 1 dog, 1gyp.

B. Jan. 23.
GILL had 11 pups. 4 died—7, 5 dogs, 2 gyps.

C. Jan. 25.
JEANNIE NO. 4 had 4 pups—1 died—3, 1 dog, 2 gyps.

D. Jan. 26.
FLIRT had 7 pups—5 died—2, 1 dog, 1gyp.

B. March, 1896.
Sent to Swan Island Club, Currituck—2 dogs. TOM/alias TOWSER, DRAKE.

A. March, 1896.
Sent to Swan Island Club, Currituck—1 slut. GYPSY died 1896.
DRAKE developed into a fine dog, is now, spring of 1897, the best dog at Currituck.
TOWSER, spring of 1897, not yet developed.

March 1.
Gyp, from B—given by Mr. Winchester to Mr. J.H. Cottman & William H. Grafflin, from Cockles Point.

March 25, 1896.
Sent to Mr. Oakley Thorne, one gyp and three dogs. C.—gyp, LADY No. 2, died Feb. 1897; dog, ROY, died Jan. 1897. A.—a dog DAN No. 2 given to William Keener, in Saltpetre, Feb 1897. B.—dog DOC, returned to Island Nov. 1, 1896, died Feb. 1897.

March 26.
Sent to Mr. Roebling, two dogs. B.—DRAKE & TURK No. 2. Delivered to Mr. Alexander Brown's man, of Back river, 2 gyps—one from C. and one from B. One gyp left at Island, from D.—KATE, Oct. 1896. This gyp turned out "no good," too shy, she was given away.
MOLLIE. Bred to FRITZ, in summer of 1896. 6 pups, 3 dogs, 3 gyps about Aug. 20, 1896.

Oct. 1896.
Dark color. 1 dog sent to Mrs. Elizabeth Lennox, 468 16th St., Brooklyn, N.Y.
Dark color. 1 dog sent to Mr. Alexander Brown. ROYAL.
Dark color. 2 gyps sent to Mr. J. Olney Norris to Swan Island Club, Currituck, N.C. GYPSY and KATE.

List of Dogs. Fall of 1896.

MOLLIE	Sire SPRIGG	Dam DAISY	
DARBY	Sire JIM	Dam BEAUTY	
JOAN	Sire JIM	Dam BEAUTY	
FRITZ	Sire TURK No. 1	Dam GRACE. John S. Gittings' slut	
GILL	Sire FRITZ	Dam JOAN	
FLIRT	Sire JIM	Dam BEAUTY	

JEANNIE No. 4	Came from Miller's Island, partly Mallory stock		
TURK No. 2	Sire DARBY	Dam GILL	Pupped Jan. 23, '96. Sent to Mr. Roebling, and returned Feb. '97.
DOC No. 2	Sire FRITZ	Dam MOLLIE	(light colored— puppy of summer 1896)
DAISY No. 2	Sire FRITZ	Dam MOLLIE	(puppy of summer of 1896)

These were the puppies sent Mar. 25, 1896, to Oakley Thorne. Returned Nov. 15, 1896.

LADY No. 2	Sire DARBY	Dam JEANNIE No. 4	Died Feb. 1897
ROY	Sire DARBY	Dam JEANNIE No. 4	Died Jan. 1897
DAN No. 2	Sire FRITZ	Dam MOLLIE	Given to Mr. Keener, Saltpetre Feb. 97
DOC	Sire DARBY	Dam GILL	Died Feb. 1897

1897.

MAC. Brought here by Josh in the spring of 1897, then one year old, and sold, by Josh to Mr. Hermann Oelrichs, in the spring of 1897, and sent to San Francisco.

In the summer of '97, FRITZ was bred to JOAN; result—4 puppies, 2 sluts and 2 dogs. The dogs were raised at the Island. Gyps were given to J. Henry Snyder, Sr., on Back river.

JOE. By DARBY out of Grace's Quarter slut, sent to Island in spring of 1897, and bred to DARBY. One of the pups was sent to the Island, we named it JOE, and sent it to Captain Barnes.

FRITZ NO. 2. By FRITZ NO. 1, out of JOAN. Turned out to be very timid, and was given away 1901.

DAN NO. 2. By FRITZ NO. 1, out of JOAN. Died in 1901.

<u>List of Dogs at the Island, fall of 1897.</u>

MOLLIE	Sire SPRIGG	Dam DAISY	
DARBY	Sire JIM	Dam BEAUTY	Died
JOAN	Sire JIM	Dam BEAUTY	Died 1897
FRITZ	Sire TURK No. 1	Dam GRACE	Given to Gibson, at Chases, in 1897
GILL	Sire FRITZ	Dam JOAN	
FLIRT	Sire JIM	Dam BEAUTY	
JEANNIE NO. 4	Came from Miller's Island, partly Mallory's stock	Died 1897	
TURK No. 2	Sire DARBY	Dam GILL	

Doc	Sire Fritz	Dam Mollie White	
Daisy No. 2	Sire Fritz	Dam Mollie White	
Joe	Sire Darby	Dam Grace's Quarter slut	Sent to Captain Barnes
Fritz No. 2	Sire Fritz	Dam Joan Smooth	
Dan No. 2	Sire Fritz	Dam Joan Wooley	

Obituary notices & c.

Fritz. Had done good service for many years. One of the best dogs ever on the Island, departed full of years and honors, he was given to Jim Gibson, our neighbor, in the fall of 1897.

Joan. Had done good service.

Jeannie No. 4. Was never thoroughly broken.

Requisicat in pace.

1898.

[missing]

1899.

List of Dogs. Fall of 1899.

Mollie	Sire Sprigg	Dam Daisy	Died, March 1901
Gill	Sire Fritz	Dam Joan	
Flirt	Sire Jim	Dam Beauty	Died 1900
Doc	Sire Fritz	Dam Mollie	Died 1900
Daisy No. 2	Sire Fritz	Dam Mollie	Died 1900

Fritz No. 2	Sire Fritz	Dam Joan	Given away—timid
Dan No. 2	Sire Fritz	Dam Joan	Died 1900
Rock	Gum Point dog	Dam Gill	Died 1900
Jack	Gum Point dog	Dam Gill	Died 1900
Turk No. 2	Sire Darby	Dam Gill	Died 1900

Gum point dog, brother of Jack. This dog Jack was from Helldorfer's [who ran a saloon at Middle River], belonged to Josh, and sold by him to Hermann Oelrichs, who sent him to California.

Rock. Pupped in summer of 1899. Sire Gum Point dog. Dam Gill.

Jack. Pupped in summer of 1899. Was full brother of Rock.

1900.

In the summer of 1900, a disease broke out among the Chesapeake dogs at the Island, and all of our dogs died from it except 3—Mollie, Gill and Fritz No. 2. Mollie recovered completely, but Fritz No. 2 and Gill are now, October 1900, very weak across the loins. December 1900, Gill much better.

Sport. October, was bought from Helldorfer, from Mallory stock. When bought was a puppy about 7 months old. Is turning into a very fine dog.

List of Dogs on Island. Fall of 1900.

Mollie	Sire Sprigg	Dam Daisy	Died March 1900
Gill	Sire Fritz No. 1	Dam Joan	
Fritz No. 2	Sire Fritz No. 1	Dam Joan	Given away 1901
Belle	Sire Darby	Dam Jeannie No. 4	Given away 1901

Sent to Island in September 1900, from Mr. Alexander Brown's shore. This gyp had been given to Mr. Brown, from the Island, in March 1896.

Appendix I

Betty purchased in Highlandtown, by Mr. J.O. Norris, in the fall of 1900. Apparently about 1 year old. Unknown pedigree. Died 1901.

Nep Sire Darby Dam Gill Died in 1902
Nep or Neptune, was sent to the Island from Currituck by Mr. J. Olney Norris, in the fall of 1900, Nep is out of Kate, was one of two gyp pups sent by Mr. J. Olney Norris to Currituck in 1896. Sire of Nep was Towser, by Darby out of Gill. Nep apparently died from poison in summer of 1902.

Rover. Brought to the Island by Josh, in fall of 1900. Owner of Rover came to Island, and took him away, Feb. 1901. Jan. 1901, Rover was bred to Mollie, Feb. 1901, Mollie miscarried.

1901.

Carpender's dog, Frick, was brought by Josh in the summer of 1901. Unknown pedigree, but of the Maxwell Club stock.

Jan. 1901. Gill bred to dog from Marshy Point; only one pup survived, born March 1. Jack No. 3 grew up to be a very promising dog. The Marshy Point dog was a very fine animal, a thoroughbred, and thoroughly trained.

Dogs on Island. Fall of 1901.

Gill	Sire Fritz No. 1	Dam Joan	
Fritz No. 2	Sire Fritz No. 1	Dam Joan	Given away, spring 1902
Sport	From Helldorfer, said to be of Mallory stock		
Belle	Sire Darby	Dam Jeannie No. 4	Given away 1902
Neptune	By Darby	out of Gill	

116

TOWSER	Sire FRITZ NO. 1	out of MOLLIE.	Died 1902
JACK NO. 3	Sire Marshy Point Dog	Dam GILL	
Carpender's FRICK	Unknown pedigree Maxwell stock		

BELLE. Bred in winter of 1901–02 to SPORT.

GILL. Bred in winter of 1901–02 to Marshy Point dog.

BELLE. Was not with pup and was given away in spring of 1902.

GILL. Had 6 pups, only 2 of which lived, in March 1902.

FRITZ NO. 2 Never having recovered from the disease of 1900, was given away in spring of 1902.

1902.

Dogs on Island. Fall of 1902.

GILL	Sire FRITZ NO. 1	Dam JOAN	Died in fall of 1902
SPORT	Unknown pedigree. Bought from Helldorfer		
JACK NO. 3	Sire Marshy Point dog	Dam GILL	
FRICK	Unknown pedigree Maxwell stock		
Wilson's FRITZ	Bought from Maddox, Buck Neck, by Mr. Wilson, in fall of 1902. Maxwell stock.		

ROCK. Presented to Carroll's Island Club in summer of 1902, by Mr. Harry Hurst, through F.C.L., was bred Lego's Point, as a puppy. Died fall of 1903.

FANNIE. Was bred to SPORT in fall of 1902. Result, 6 pups, born November 1902. 1 died. JEFF, ROSE, KATE, kept on Island. 1 dog and a bitch sent to Mr. Hughlett of Eastern Shore.

| HARRY | Sire FRICK | Dam Marshy Point bitch | |
| JOE | Sire FRICK | Dam Marshy Point bitch | Died 1902 |

HARRY. A light colored Chesapeake bay was brought to the Island in the spring of 1903, when one year old, by Mr. Harry Parr. A very fine looking dog. JOE NO. 2. A full brother of HARRY. Dark colored, fine looking dog.

1903.

Dogs on the Island. Fall of 1903.

SPORT	Unknown pedigree Mallory stock		
JACK NO. 3	Sire Marshy Point dog	Dam GILL	
FRICK	Unknown pedigree Maxwell stock		
Wilson's FRITZ	Mallory stock		
FANNIE	Unknown pedigree		
JOE NO. 2	Sire FRICK	Dam Marshy Point bitch	
HARRY	Sire FRICK	Dam Marshy Point bitch	

ROSE	Sire SPORT	Dam FANNIE	Given away
KATE	Sire SPORT	Dam FANNIE	Given away in 1904
JEFF	Sire SPORT	Dam FANNIE	incurably gun shy
NELLIE, Newkirk's dog	a son of DARBY	Dam a daughter of ROSE, changed to ZIP	

December 1903. FANNIE had 6 pups, 3 dogs and 3 bitches by JACK No. 3. These pups, through JACK, restores the old stock. FLOYD, SHOT, GILL No. 2, JEANNIE No. 4, BESS, ROVER, JOSH took latter.
Pups. 3 dogs, 2 sluts, by JACK out of FANNIE.

Future Sires.
JACK No. 3. this dog combines the best blood of the Carroll's Island stock. He was pupped March 1901. He is rather dark liver color, wavy haired… GILL was rather light colored, wavy hair…GRACE belonged to John S. Gittings, was of the Lego Point strain, and had been bred by Dr. Keener, from the celebrated Keener's Rose stock…TURK was a very fine dog, a beautiful specimen of a Chesapeake Bay, and was immortalized by an artist Tracy who visited the Island, and painted him in an oil picture— retrieving a goose…SPORT, a dark liver colored dog, has turned out to be a remarkably fine Chesapeake, most of his work (1903), is done on the Bar. He is a fine retriever.

1904.

Dogs on the Island. Fall of 1904.

SPORT	Unknown pedigree	Mallory stock
JACK No. 3	Sire Marshy Point dog	Dam GILL
Wilson's FRITZ	Mallory stock	

| FANNIE | Unknown pedigree | |
| HARRY | Sire FRICK | Dam Marshy Point bitch |

PUPS

ROSE, LOU, JENNIE No. 3, DAN No. 3, JEFF No. 2 (Sire JACK, dam FANNIE) These pups are turning out remarkably well. DAN, Mr. Carpender has taken charge of; he is curly haired, but will now bring out ducks (spring of 1905). JEFF, Mr. Ty Norris's charge, is 1st class, he is straight haired, very much like JACK, his sire, brings out ducks at the Bar and promises well. JENNIE, F.C.L.'s charge, straight haired, looks like JACK. His sire, also brings out ducks. No doubt LOU & ROSE will do the same. These 5 pups, through JACK and GILL, carry on the old stock, including the great DAN, FRITZ, JOAN & c.

1905.

Dogs on Island. Fall of 1905.

SPORT	Mallory stock		
JACK No. 3	Sire Marshy Point dog	Dam GILL	
Wilson's FRICK		Mallory stock	
FANNIE	Pedigree unknown		
HARRY	Sire FRICK	Dam Marshy Point bitch	
DAN No. 3	Sire JACK No. 3	Dam FANNIE	Dead
JEFF No. 2	Sire JACK No. 3		
ROSE No. 2	Sire JACK No. 3	Dam FANNIE	
LOU	Sire JACK No. 3	Dam FANNIE	Dead
JENNIE No. 3	Sire JACK No. 3	Dam FANNIE	Dead

DRAKE. Brought to Island by Wm. McKay from his late father's ducking shore, in the fall of 1905. A thoroughly trained dog. Unknown pedigree.

1906.

Dogs on Island. Fall of 1906.

SPORT	Mallory stock	
JACK No. 3	Sire Marshy Point dog	Dam GILL
Wilson's FRITZ	Mallory stock	Died in fall of 1906
FANNIE	Unknown pedigree	
HARRY	Sire FRICK	Dam Marshy Point bitch
JEFF No. 2	Sire JACK No. 3	Dam FANNIE
ROSE No. 2	Sire JACK No. 3	Dam FANNIE

Dog puppy brought to Island by Mr. Irvin Brown.
SPORT is playing out, spring of 1907, after good service.

1907.

In the summer of 1907, a disease broke out among the dogs at the Island, which carried off SPORT, FANNIE, HARRY, and ROSE No. 2. Leaving only JACK No. 3 and JEFF No. 2. SPORT was a very fine dog. He died after long and valuable service.

Dogs on Island. Fall of 1907.

JACK No. 3	Sire Marshy Point dog	Dam GILL
JEFF No. 2	Sire JACK No. 3	Dam FANNIE

ROVER. Josh has a very fine 8 months old dog, called ROVER, which he got from Edgewood. Bought from him by Mr. Norris for Club, came from Harford county. Maxwell's stock. Fall of 1907.

TEAL. Purchased by the Club, fall of 1907. Biddison stock.

NELLY. Brought to the Island by Dr. Hardcastle, from Easton, Talbot county, fall of 1907. Capt. J.G. Morris stock, 3 months old in November 1907.

GINGER. As above. About 8–9 years old in November. Served by Jack No. 3 in November.

KATY. Purchased for Club in fall of 1907. Same mother as TEAL. Biddison stock. Bought by Mr. J.O. Norris.

JOE. Brought to Island by Dr. Hardcastle. Son of GINGER. Sire Biddison's TEAL.

1908.

Dogs on Island. Fall of 1908.

JACK No. 3	Sire Marshy Point dog	Dam GILL	Died
JEFF No. 2	Sire JACK No. 3	Dam FANNIE	
TEAL	Biddison stock		
NELLY	Capt. J.G. Morris stock		
KATY	Same mother as TEAL		
GINGER	Capt. J.G. Morris stock		
JOE	Dam GINGER	Capt. Morris stock	
ROVER	Maxwell stock		
3 pups	Sire JACK No. 3	Dam GINGER	

ROSE, ROCK, CARROLL. These 3 pups go back through JACK No. 3 to our original stock.

Appendix II

Excerpts from the Carroll's Island Game Books and Daily Journals

Season of 1883–84

FEBRUARY 8, 1884
Mr. Higgins Killed two SWAN flying over the Bar—one falling dead in the Bar, the other falling on the ice in White Oak. John got him by walking on the ice & pushing boat ahead of him.

FEBRUARY 12, 1884
From 8th to 12th Rain & fog above—drifting ice & mud below. Occasional bunches of ducks wandering about without defined purposes except to avoid being shot at—Record in this page represents 4 days. Mr. Higgins & Mr. Barnes leave today having exhausted the library & worn out the cards. Too much weather—

MARCH 4, 1884
Wind N.W. to W. intensely Cold— Ther. 14°—good many ducks moving looking for chances to feed—thought so little of appearance—laid abed until sun up—had breakfast—went to the Bar—killed 2 canvas backs—seeing a large rick of ducks under Weir Point, went over after midday meal put out decoys with the effect of starting all the ducks up the river—accordingly went back to the Bar & had a very enjoyable afternoon—killing 23 good ducks—day ends cold.

Appendix II

Season of 1884–85

Now Ducks and Geese keep off the land
Beware of Bar and Shore
These ardent Sportsmen ready stand
To shed your crimson gore
House was opened October 10th with the old couple of servants—Boats,
Blinds and Decoys all in good order

November 2
—Programme—
Part I
Drinks---------------------Everyone
Part II
More Drinks---------------------the same
Part III
Many More Drinks---------------------Do Do
Part IV
Song "When the robins rest again----Skip----G.----
Part V
Dance "Tra la la-----------------------F.C
Part VI
Prayer "many more drinks"----R.G.
(intermission of ten minutes to unload)
Part VII
Effect of Blue glass in our Stomach----Hermann Oelrichs
Part VIII
General reloading followed by
Chaos & Oblivion!

November 4
9 Ducks killed for the day.
Three cheers for our next
President
Grover Cleveland!
So say we all of us—

NOVEMBER 22
A large eagle was killed on the Bar while carrying off a redhead—both duck & eagle were bagged.

1887

NOVEMBER 1
Captain Joseph Pinney in charge of all outdoor shooting arrangements with Joshua Wilkinson & John Johns as assistants—Thomas Potter, steward & Susan Brown cock—William Russell in charge of horses and transportation, Mrs. Rupert chambermaid & in charge of bedrooms.

1888

MARCH 9
At 1 o'clock today Capt. Pinney come out of his sitting room & reported House on Fire. Sure enough things in the wall & chimney of our dining room, & Capt. Pinney's sitting room were in a good blaze; all hands were quickly on the spot & not excited (except the woman cook) after cutting away the mantle & lath work in "Pinney's room" & the wash board in "Potter's room" above, with pails of water applied with a dipper & over hand—we succeed in putting out the Fire—had the stove in the dining room removed, to examine things thoroughly—all safe for the night— shall send carpenter & stove man to repair damage, and duly notify Insurance Companies to Pony Up!! J.O. Norris

APRIL 8
Close of the Season—embracing these facts. The fall shooting, up to the time the ducks left, was unusually poor. The ducks were few in number and made poor shooting at that—Bay cove was very little resorted to by ducks—on the other hand the spring shooting, although opening late after a long cold winter, has been uncommonly good—The ducks have been very abundant and well distributed partly [due to] poor fall shooting, but mainly to the very small attendance of members; there have rarely been more than three or four at the Island at a time, and on many days of the best shooting, there have been but one or two and some of the most effective guns have not been heard here during the entire Season—We must add to this, that the neglect of keeping an accurate record of each

day's shooting, has been more marked than ever before—on this closing day, Norris, Latrobe & Carter, are at the house. We leave everything in complete order, the birds have all gone, the day is beautiful & enjoyable and we depart in happy expectation of a re-union next October—At least 350 ducks and 15 or 20 geese have been shot and not recorded during the Season owing to the negligence of the members in keeping up the record. [The recorded total for the season was 1,211.]

October 15

The club house has been opened for the season—October 15, 1888. Norris & Latrobe came down on evening of the 13th and spent the night, giving up the afternoon of the 14th to see everything ready—All employees on duty—

December 8

A great many ducks have been bedded for several days in Bay cove but left this P.M. some down the bay, some up the Gunpowder—A practical looking craft anchored off Spry's last evening & is now in Sugar cove—some funny business in hand.

December 22

Tried for some Xmas ducks with only poor success, mostly 'mongrels'—Ice making fast all around the Island. Most of the coves for several days past.

Opening of the Season of 1889–90

Mr. F.C. Latrobe came down this Saturday October 12, 1889 to open the Club House—Everything is now ready for the Members—Thomas Potter is steward with an assistant—The attendants are Josh—John and Amos—boats, decoys, blinds are all in good condition—there are four well trained Dogs ready for service—Jeannie, Burk, Jack and Turk—with 3 others Fred, Zip and Duck coming on—The day (Saturday Oct 12) was beautiful, clear & mild light southerly wind—there are a great many ducks in Saltpetre, Bengies Cove and Gunpowder—Redheads and Baldpates—More than for some years past at this date—No ducks flying over the Bar, but thousands of them up Saltpetre & Gunpowder

1891

NOVEMBER 7

Name:	A. Higgins
Remarks:	First the Clubhouse and all the surroundings in elegant order, thanks to our very "efficient" executive—weather fine but as to "duck shooting"!!! Alas! Alas! Killed 5 woodcock in the swamps—

NOVEMBER 28

Name:	J. Olney Norris, F.S. Dickson
Locality:	Bar
No of Guns:	2
Game Killed:	2 S W A N
Wind:	Southerly
Weather:	Overcast
Remarks:	Several swan, all old ones crossed between Nos. 3 and 5. Mr. Norris fired at the second bird, Mr. Dickson at the leader. Both birds fell dead about 100 yards out, and within 100 feet of each other.

1892

MARCH 15

Name:	Jas. C. Carter
Locality:	Schultz Point
Game Killed:	16 redheads
	1 blackhead
	1 bald pate
	1 Ruddy duck
	19 Total

Remarks:	Same story. Cold weather and no water and ice. Part of decoys [blown by] wind. The seat frozen in. Spent two hours in cleaning ice out & waiting for water with ducks flying all around me. But for ice and want of water could have had fine shooting.

MARCH 26

Name:	Norris, Latrobe, & Barnes—son
Locality:	Schultzes & Haw cove
No. of Guns:	4
Game Killed:	30 Redheads at Schultz Norris & Latrobe
	2 Baldpates "
	18 Redheads at Haw Cove Barnes
	6 Blackheads "
	2 Canvasbacks "
	Afternoon
	21 Redheads at Schultz
	2 Redheads on Bar
	81 Total
Wind:	NE
Weather:	Cloudy and rain
Remarks:	A good many ducks in Saltpetre, Seneca & Haw cove—the Brood still survives—no fault could be found with the ducks, it only requires good shooting to get big bags.

1893

MARCH 6

Name:	Norris & Roebling
Locality:	Bar
Game Killed:	2 Drake Canvasback
	2 Redheads
	2 Blackheads
	6 Total
Remarks:	(A penciled in note.) Twenty years from now what will be the outlook on Carroll's and how many of the present members will be enjoying life?

OCTOBER 22

Name:	J. Olney Norris & F.C. Latrobe
Locality:	Bar
Game Killed:	1 Canvas Back
	1 Black Head
	9 Red Heads
	1 Yellow legged Plover
	12 Total
Wind:	North East
Weather:	Cloudy
Remarks:	First shooting day of the Season. Saw good many Ducks coming from Bay & over Lower Island—about 3 or 4 bunches crossed the Bar, out of which we got the above. Having all the ducks we wanted, we left the Bar at 7:30AM. Saw several bunches cross after we came up, but our object in stopping shooting was to let the Ducks settle about the Island for our friends when they came down—Prospect for the season looks promising.

1894

OCTOBER 18

Name:	F.C. Latrobe
Locality:	Bar
Weather:	Soft & warm
Remarks:	Saw 2 or 3 good bunches of ducks, none settled in our waters. Have arranged all my 'things' for the season.

1896

OCTOBER 25

Name:	F.C. Latrobe, J.O. Norris, J.T. Norris
Locality:	Bar
No. Of Guns:	3
Game Killed:	3 Mallard
	1 Goose
Wind:	NW
Weather:	Very Clear
Remarks:	Sharp frosty night, geese and swan are here. Some ducks seen on Friday past—very few today. Opening of the season, boats & decoys will be distributed this week—everything ready for members.

OCTOBER 31

Name:	Norris, Latrobe, Manchester
Locality:	Lower Island & Bar
Game Killed:	1 Blackduck

	2 Large Hoot Owls
Wind:	S
Weather:	Fair
Remarks:	Warm, mild, flys, mosquitoes & knats. Picnic weather.

NOVEMBER 6

Names:	Norris & Latrobe
Locality:	Bar
Game Killed:	2 Geese}
	5 Redheads} Good Luck from Good Shooting
	1 Baldpate}
	3 Fisherman}
Wind:	NW
Weather:	Fair
Ther.	54°
Hour Noted:	12 noon
Remarks:	The highest tide known on the Island since '93 water all over marshes & road from Standing cove to near 1st gate near stable. Looks like ocean over the road waves actually breaking—Like Noah's flood—

NOVEMBER 7

Name:	Wilson & Norris
Locality:	Everywhere
Game Killed:	3 Geese
	1 Blackduck
	4 Total
Wind:	South

Weather:	Warm
Remarks:	<u>Still</u> <u>No</u> <u>Ducks</u>!! in these waters! A few are flying around but do not settle. More <u>geese</u> than usual.

Nov. 15–16

Name:	Norris, Norris, Latrobe, Wilson
Locality:	Bar & Lower Island
Game Killed:	4 Geese
	3 Swan
	2 Blackducks
	1 Mallard
Wind:	South
Weather:	Fair—Calm
Remarks:	Very few ducks but more geese and swan than have been here for many years in fact more than ever in the recollection of any members of the Club.

NOVEMBER 21

Name:	Wilson & Latrobe
Locality:	Bar & Lower Island
Game Killed:	3 Swan (Killed at one shot) (Bunch at Weir Point)
	2 cygnets & 1 old bird out of a bunch of five
	1 Baldpate
	4 Whifflers
	1 Black Duck
Wind:	morning NE
Rain	
Weather:	Evening S.W.

	Cloudy
Remarks:	A great bunch of large game swan & geese, but no ducks on our waters.

NOVEMBER 22

Name:	Wilson, Norris, Norris, Floyd-Jones, Carpender, Latrobe
	Wilson at Bar Point, Latrobe & Norris at Lower Island & Weir Point
Locality:	Lower Island—Bar Point
Game Killed:	7 Swan
	1 Dipper
	1 Blackhead
	1 Whiffler
Wind:	North
Weather:	Cool rain in morning clearing off by sunrise
Ther.	48°
Hour Noted:	12 noon
Remarks:	Mr. Wilson killed 6 swan at Bar Point. This is the largest number of swan killed to a single gun of which there is any records at the Island—one swan killed at Lower Island—a great many swan & geese in our waters—but as yet no ducks—Mr. Wilson is champion now—

NOVEMBER 23

Names:	D. Floyd-Jones & Carpender
Game Killed:	6 Partridges
Hour noted:	Noon

Remarks:	No Ducks shot.

DECEMBER 28

Name:	D. Lanier
Locality:	Weir Point
No. of Guns:	1
Game Killed:	11 Mallards (black mallards & green head)
	2 redheads
	2 baldpates
	15 Total
Wind:	NE, NW & SE
Weather:	Fair like to no wind
Ther.	twelve to thirty above
Remarks:	Two bunches of canvasbacks (5&6 birds) passed over stool, rather high. Ice halfway to Sprys island until tide split it up. Counted with aid of field glasses 39 & swan from bar point past Rickets point to Sprys. More off Lower Island and geese innumerable—a disgraceful number of cripples fell in ice and could not be reached.

1897

JANUARY 10

No.	1 Well of water
Remarks:	Drove well for water near garden fence. So far a plentiful supply. Depth about 14 feet.

Excerpts from the Carroll's Island Game Books and Daily Journals

MARCH 13

Name:	Gov. Griggs, Roebling, Latrobe, Marburg, Prof. Rimren [?]
Remarks:	Great many ducks in Saltpetre. The three swan were killed in Haw Cove at one shot by the governor of New Jersey… about 57 other swan were badly frightened.

MARCH 15

Name:	Barnes & J.O. Norris
Locality:	Bar & Haw Cove
Game Killed:	10 Redheads
	1 Blackhead
	1 Baldpate
	4 Swan Haw Cove
	16 Total
Wind:	W to NW
Weather:	Clear & cool
Ther.	32°
Remarks:	Gave the ducks a day's rest on Saltpetre side. All decoys up last eve!

MARCH 21

Name:	J.O. Norris, I.T. Norris, Wilson, Flint, Latrobe
Locality:	Bar, Schultz, White Oak, Stubby
Game Killed:	40 Redheads
	8 Blackheads
	2 Geese
Wind:	East
Weather:	Thick Fog

Ther.	32°
Remarks:	There was a thick fog until about 12 noon—ducks would not come to Bar, but decoy blinds were fairly good.

APRIL 4

The season of 96 & 97 has now closed. There were very few ducks killed in the Fall, as shown by the record. There was more big game swan & geese in the fall of 96 than ever before known at the Island. The record will show 25 swan & 17 geese. The spring shooting was very good, a great many ducks were on our waters from the last of February to the end of March—redheads, blackheads, some canvasbacks and plenty of blackducks—there were however very few baldpates—the number of coot about the Island increased this spring—on the whole we have had good company and a good time.

NOVEMBER 13

Name:	Messers. Wilson, Latrobe, J.O. Norris, I.T. Norris & Lanier	
Locality:	Lanier on Bar	
Game Killed:	1 pheasant	J.O. Norris
	1 pheasant	I.T. Norris
	1 pheasant	Latrobe
	1 Goose	Lanier
Wind:	NW	
Weather:	fine changing to rain	
Ther.	30°	
Hour Noted:	5:30 am	
Remarks:	No ducks, geese still coming in.	

NOVEMBER 14 & 15

Name:	C.D. Lanier

Game Killed:	2 Quail
	20 Blackheads
Weather:	fine for shooting but nothing to shoot
Remarks:	On the morning of the 15th 3 bunches of baldpates crossed the bar high many geese and the first crowbill of the season and also saw several in the good sized flocks one in Bay Cove one in Bay.

1898

FEBRUARY 12

Name:	Wilson, Winchester, Norris
Locality:	White Oak Bar
No. of Guns:	5
Game Killed:	22 Redheads
	5 Mallards
	1 Mink
	2 Muskrats
Wind:	S
Weather:	Soft & Warm
Remarks:	A great many ducks came but left the next day for other waters.

March 20

Name:	Marburg & Friend, Winchester, Wilson, Latrobe, I.T. Norris
Locality:	Bar Stubby
No. of Guns:	5
Game Killed:	38 Redheads

	11 Blackheads
	49 Total
Wind:	SW & NW
Weather:	Warm cloudy
Ther.	55°
Hour	9AM
Remarks:	Ducks came from river to Bay Cove. Very unusual flight.

1899

NOVEMBER 16

Name:	Theodore Marburg
Locality:	Bar Point
No. of Guns:	1
Game Killed:	1 Baldpate
	1 Fisherman
	1 Whiffler
	1 Hen Pheasant
	1 Butterball
	2 Partridges
	7 Total
Wind:	North
Weather:	Clear
Remarks:	Numbers of coots making up. Several bunches of black heads went over, geese in great numbers bedded above and swan beginning to arrive. Josh remarked that coots were more numerous than for three years.

1900

JANUARY 20

Name:	Theo Marburg
Locality:	Stubby
No. of Guns:	1
Game Killed:	1 **Swan!**
Wind:	W & SW
Weather:	foggy & clearing
Ther.	50°
Remarks:	Ice out of Gunpowder but on Seneca side still holding in the soft—

MARCH 11

Names:	Carpender, Stevens, Norris, Lanier
Locality:	Schultz & Bar
Game Killed:	1 Fisherman (Schultz)
	1 Muskrat (crossing bar)
Wind:	NE
Weather:	Mild
Bar.	29
Ther.	40°
Remarks:	Snow in the afternoon

NOVEMBER 8

Name:	Com. Floyd-Jones, C.D. Lanier
Game Killed:	5 pheasants
	14 quail

	1 rabbit
Wind:	NW
Weather:	getting cooler
Ther.	34°
Remarks:	Shooting at Grace's Quarter & consequent disturbance of 200 to 300 ducks that have been bedded off Battery Point.

1901

JANUARY 12

Name:	C.D. Lanier & guest
Locality:	Bar
Game Killed:	2 redheads
Wind:	NW to SE
Weather:	mild
Ther.	34°
Remarks:	The ducks in Bay Cove, numbering 600 to 1000 redheads & widgeons, insisted on staying right where they were. In the very little flying they did, the birds were too high.

NOVEMBER 10

Names:	Winchester, Norris & Lanier
Locality:	1 mornings shoot
	Bar & White Oak
Game Killed:	1 Canvasback
	2 Woodcock
	5 Redheads

	8 Rabbits
	4 Blackheads
	1 Fisherman
	2 Swan
	1 Coot
Wind:	NW
Weather:	Fair & blowing hard
Ther.	
Remarks:	A lot of ducks in Bay Cove, White Oak Hollow, Gunpowder & Saltpetre, if weather had been different there should have been very good shooting.

1902

MARCH 24

Name:	C.D. Lanier
Game Killed:	1 redhead
	1 baldpate
	2 Total
Wind:	NE
Weather:	very mild
Ther.	40°
Hour noted	5 AM
Remarks:	Picnic weather, between 500 & 1000 ducks in Grace's Quarter Hollow many blackheads & baldpates.

Appendix II

Name:	Latrobe, Floyd-Jones, Marburg, Carpender
Locality:	Bar, Weir Pt., Stubby, Lower Is. Bar
Game Killed:	1 Swan (aged)
	1 Widgeon
	7 Blackheads
	1 Fisherman
	4 Redheads
	1 Ruddy duck
Wind:	South
Weather:	Very mild

DECEMBER 3

Name:	T. Marburg
Locality:	Stubby
Game Killed:	3 Redheads
	1 Mallard
	3 Ruddy
	1 Crow Bill
	8 Total
Wind:	West
Weather:	Grey
Remarks:	One big bunch of several hundred swept by, others came in singles. Have never seen such large flights as came in Hawk cove yesterday.

1903

MARCH 9

Name:	Carpender & Steven
Locality:	Schultz & Stubby
Guns:	2
Game Killed:	14 canvasbacks
	15 redheads
	7 blackheads
	2 widgeons
	2 sprig tails
	1 green teal
	2 black ducks
	2 whistlers
	1 kildeer
	36 Total
Wind:	S.E. Very Little
Weather:	Cloudy
Bar.	30.2
Ther.	48°
Hour Noted:	5 AM
Remarks:	Wind north—after 7 a.m.

MARCH 17

Name:	Theo Marburg
Locality:	White Oak
Game Killed:	3 geese
	5 Redheads

	1 Baldpate
	9 Blackheads (creek)
	18 Total
Wind:	N.E
Weather:	raining
Remarks:	Geese came up to the decoys.

MARCH 25

Name:	J.O. Norris
Locality:	White Oak
Guns:	1
Game Killed:	52 Blk Heads—½ Bay
	5 Red
	3 Mallard
	60 Total
Wind:	W x NW
Weather:	Clear
Bar.:	High
Ther.	44°
Hour noted	5 PM
Remarks:	Only shot during the forenoon, back at house by 9:30 AM. Could have killed 100—"I think"

NOVEMBER 23

Name:	Carpender, Marburg and guest
Locality:	Schultz, Hawk Cove
Guns:	3
Game Killed:	2 Canvas Back

	15 Redheads
	1 Ruddy
	1 Goose
	1 Snipe
	1 Black-head
	21 Total
Wind:	West then South
Remarks:	Ricks of several thousand ducks in Bengies Cove.

DECEMBER 16

Name:	Weiskittel
Locality:	Schultz
Game Killed:	9 Redheads
	1 Canvasback
	1 Green mallard
	1 Baldpate
	1 Crowbill
	13 Total
Wind:	NW
Weather:	Cold & cloudy
Remarks:	Ice all over Saltpetre but some bunches, pairs, & singles decoyed, decoys being frozen in. Lost 5 Baldpates, 1 Redhead & 1 canvasback which fell wide other wounded they were too wide for the dogs to get back out to.

1904

MARCH 14

Name:	Theodore Marburg
Locality:	Schultzs
Game Killed:	16 Redheads
	1 Whiffler
Wind:	N.E.
Weather:	Snowing
Remarks:	Ducks came in five bunches & decoyed well. Seven down at one time, four at another.

MARCH 27

Name:	Marburg, Hardcastle & guest
Locality:	Schultz, White Oak
Game Killed:	1 Redhead
	14 Blackheads
	1 Fisherman
	16 Total
Wind:	N &NW
Weather:	Snow in morning
Remarks:	Tide very low in morning & ducks decoyed badly. Very little shooting in afternoon.

NOVEMBER 1

Name:	Theo Marburg
Locality:	Schultz

Game Killed:	1 Young Goose
Remarks:	Shot in the evening when almost too dark to shoot, two flew about it came to man called them.

NOVEMBER 10

Name:	T. Marburg
Locality:	White Oak
Game Killed:	2 Redheads
	1 Canvasback
	3 trash ducks
	6 Total
Wind:	North
Weather:	Cloudy
Remarks:	Plenty of ducks in bay but did not care to make the acquaintance of the stool.

1906

MARCH 30 & 31

Name:	Hardcastle & guest
Locality:	White Oak
Game Killed:	12 Redheads
	1 Baldpate
	5 Blackheads
	18 Total
Wind:	NE
Ther.	40°
Hour Noted	AM

Remarks:	Very hazy. Plenty of ducks moving early & late but pay no attention to decoys.

Names:	Hardcastle, Norris, Marburg, Carpender
Locality:	Bar, White Oak, Schultz
Game Killed:	6 Redheads
	3 Blackheads
	2 Baldpates
	1 Blackduck
	10 Ruddys
	22 Total

1907

MARCH 7

Name:	Marburg
Locality:	Weir Point, Bar & White Oak
Game Killed:	2 Mallards
	2 Creek Blackheads
	1 Whiffler
	2 Baldpates
	19 Redheads
	26 Total
Wind:	S.E.
Remarks:	Walked on the ice from Weir Point to Bar. Big rick of ducks at Grace's Quarters.

1908

MARCH 28

Name:	Marburg
Locality:	White Oak
Game Killed:	12 Creek Blackheads
	2 Ruddies
	14 Total
Wind:	S.E.
Remarks:	Ducks on bait for first time after it had been out several weeks.

1909

MARCH 12

Name:	Thom. Cottman, J.H. Cottman
Locality:	Schultz
Guns:	2
Game Killed:	45 Redheads
	25 Blackheads
	70 Total
Wind:	N & NE
Remarks:	Beautiful shooting, all ducks killed before 11 o'clock.

1911

NOVEMBER 15

Name:	Theodore Marburg

Locality:	Schultzes
Game Killed:	4 Redheads
	4 Blackheads
	2 Ruddies
	1 Cygnet
	11 Total
Wind:	South
Remarks:	Swan (old one & family of young) drifted past blind.

DECEMBER 2

Name:	Marburg
Locality:	White Oak
Game Killed:	1 Canvasback
	2 Ruddies
	1 Black duck
	4 Total
Wind:	South
Remarks:	Very few ducks about. Night shooting on the water reported by men.

1912

NOVEMBER 7

Name:	Marburg
Locality:	Weir Point
Game Killed:	2 Creek Blackheads
	2 Butterballs
	3 Whifflers
	3 Fisherman

	10 Total
Wind:	E
Weather:	Raining
Remarks:	Considerable number of swan, geese & black ducks off lower island. Saw only one flight (small) of redheads & small flight of blackheads.

NOVEMBER 11

Name:	Marburg
Locality:	Weir Pt.
Game Killed:	5 Swan (all cygnets)
	3 Redheads
	2 Blackheads
	1 Butterball
	1 Black Duck
	12 Total
Wind:	South
Remarks:	Great quantities of geese & swan. The swan killed flew over the blind.

1913

JANUARY 1

Name:	Barnes, Warfield, Wheelright & Macgill
Locality:	Bar & Stubby
Game Killed:	3 Canvas Backs
	4 Red Heads
	4 Black Heads

	1 Whiffler
	12 Total
Remarks:	Lots of Canvas Backs & Red Heads. No wind & warm.

MARCH 4

Name:	Floyd-Jones & Carpender
Locality:	Schultzes & White Oak
Game Killed:	10 Blackheads
	1 Black duck
	11 Total
Wind:	From the W.
Weather:	Mild
Ther.	38°
Hour noted	6 AM

APPENDIX III

RECIPES

IN THE STYLE OF THE CARROLL'S ISLAND KITCHEN FROM FIFTY
YEARS IN A MARYLAND KITCHEN BY MRS. B.C. HOWARD

While none of "Joseph's recipes" have survived, John Stuart Skinner described the culinary code of the Carroll's Island kitchen in Slater's day to be that found in Mrs. Ben Howard's famous cookbook. These recipes are from that volume.

WILD DUCKS

Pick and clean the ducks, catching the blood that runs from them on a dish so that it can be used. About twenty minutes before they are to be served, put them down to cook. It is better to put them inside the range than before the grate. Lay them flat in a dry pan without water. When done, and while very hot, stir quickly into the essence that has run from them the blood that was saved when cleaning them. The hot essence cooks the blood sufficiently. Pour this gravy *inside* the ducks and serve very hot.

Redheads require eighteen to twenty minutes, canvasbacks twenty-three to twenty-five minutes.

TERRAPINS

Boil the terrapins until very tender and the flesh is ready to drop from the toes. Pour about a quart of cold water on them when taken out of

the boiling water. Then pick them, and if the water that runs out of the shell is not sufficient to make your gravy, add what is necessary of the cold water that has been poured on them when taken out of the pot.

To one quart of terrapins, take a large tablespoonful of butter. Half the butter must be put with them when they are put to stew, which enriches the terrapins all through, and the other half worked with a very little flour, just sufficient to thicken it, stirred in at the last. Put this butter and flour in a skillet until it becomes hot and quite a brown color; add it then to the terrapins. Season with pepper, salt, three cloves and six allspice to each quart. If you like wine, stir in a glass when ready to be served, or a pint of cream if you prefer it, or you need not put either. The yolk of an egg beat into the gravy enriches it.

SOURCES

The Baltimore Bench Show. *The Rod and Gun and American Sportsman* 9, no. 15 (January 13, 1877): 229.

Baltimore County Assessment Records, Assessor's Field Book for 1841.

Blogg, Percy Thayer. *There Are No Dull Dark Days*. Baltimore: H.G. Roebuck & Son, 1944.

Carroll's Island Ducking Club. Minutes 1851–1865. G1628 (microfilm). Baltimore County Public Library.

———. Visitors Book; Game Books; Daily Logs; Record of Game Killed. MS 2807. H. Furlong Baldwin Library, Maryland Historical Society, Baltimore.

"The Chesapeake Bay Dog." *Forest and Stream*, November 28, 1889, 367.

Department of the Army. U.S. Army Research, Development and Engineering Center, Aberdeen Proving Ground, Maryland. Historic photographs, maps, leases, aerial images and news items on Carroll's Island.

Dorsey, John. *Mount Vernon Place*. Baltimore: Maclay & Associates, 1983.

"Duck Shooting on the Chesapeake Bay." *American Turf Register and Sporting Magazine*. 4, no. 12 (August 1833): 629–36.

Editor's Note. *American Turf Register and Sporting Magazine* 6, no. 4 (December 1834): 189.

Fleckenstein, Henry A., Jr. *Decoys of the Mid-Atlantic Region*. Exton, PA: Schiffer Publishing Limited, 1979.

"Flying Kite. To the Members of Carroll's Island Wild Fowl Shooting Club." *American Turf Register and Sporting Magazine* 1, no. 2 (October 1829): 95–99.

"Great Shooting." *American Turf Register and Sporting Magazine* 1, no. 8 (April 1830): 415.

Grinnell, George Bird. *American Duck Shooting*. New York: Forest and Stream Publishing, 1901.

Howard, Mrs. B.C. *Fifty Years in a Maryland Kitchen*. Baltimore: Turnbull Brothers, 1877.

Inventory of the Property held by Nicholas Carroll upon his death, July 2, 1812. MS 2634. H. Furlong Baldwin Library, Maryland Historical Society, Baltimore.

Latrobe, Ferdinand Claiborne, II. *The Gentlemen of Long Boots and Long Barrels*. Baltimore: John H.B. Latrobe, 2006.

Letter of William B. Hurst of John E. Hurst & Co. to the Board of Control and Review for Harford County, October 15, 1896: From the collection of C. John Sullivan Jr., author.

Manson, George J. *The Sporting Dictionary*. New York: The Humboldt Publishing Co., 1895.

Sources

Marksman. *The Dead Shot; or, Sportsman's Complete Guide: Being a Treatise on the Use of the Gun, with Rudimentary and Finishing Lessons in the Art of Shooting Game of All Kinds: Pigeon Shooting, Dog-Breaking, etc.* New York: W.A. Townsend, 1864.

"Maryland Ducking Clubs." *Forest and Stream*, January 11, 1877, 365.

"Note to the Editor of the Sporting Magazine." *American Farmer* 11, no. 27 (September 18, 1829): 215–16.

Petition of Allen Thomas and other citizens of Baltimore County to the General Assembly of Maryland, dated February 18, 1833. Transcribed copy in the personal papers of the Latrobe family.

Power, Tyrone. *Impressions of America, During the Years 1833, 1834, and 1835.* London: Richard Bentley, 1836.

Public Comment Response of the North American Gamebird Association, et al. to the Final Draft of the "Review of Captive-Reared Mallard Regulations on Shooting Preserves" Published by the U.S. Fish & Wildlife Service of the United States Department of the Interior. December 20, 2003.

Russell, William Howard. *My Diary North and South.* Boston: T.O.H.P. Burnham, 1863.

Skinner, J.S. *The Dog and the Sportsman.* Philadelphia: Lea & Blanchard, 1845.

Smith, Harry Worcester. *A Sporting Family Of The Old South with which is included Reminiscences of A Old Sportsman by Frederick Gustavus Skinner.* Albany, NY: J.B. Lyon Company, 1936.

"Sporting Olio." *American Farmer* 11, no. 31 (October 16, 1829): 246–47.

"Wild Fowl Shooting." *The Rod and Gun and American Sportsman* IX, no. 11 (December 16, 1876): 168.

FOUNDING DONORS

Kaye Brooks Bushel
John L. Clayton Jr. and Dara Marie Clayton
William and Paige Cox
Henry A. Fleckenstein Jr.
Robert F. Freeze Jr.
Robert H. Geis Jr.
J. Fred Glose and Jean C. Gose
Jeanette Marie Glose and Ralph V. Partlow III
Robert N. Hockaday Jr.
C.A. Porter Hopkins
Joseph Preller
John and Patti Proctor
John V. Quarstein
Margaret Anne Reel
Michael and Gloria Silver
Henry and Judy Stansbury
Wilton P. Stansbury and Karen Stansbury
Vance and Nancy Strausburg
C. John Sullivan Jr.
C. John Sullivan III and Mary C. Sullivan
Sara Robinson Sullivan
Patrick and Jeanne Vincenti
Alfred L. Williamson and Christine C. Roberts

Visit us at
www.historypress.net
..

This title is also available as an e-book

www.ingramcontent.com/pod-product-compliance
Lightning Source LLC
Chambersburg PA
CBHW060816100426
42813CB00004B/1100